The Frick Collection / A Tour

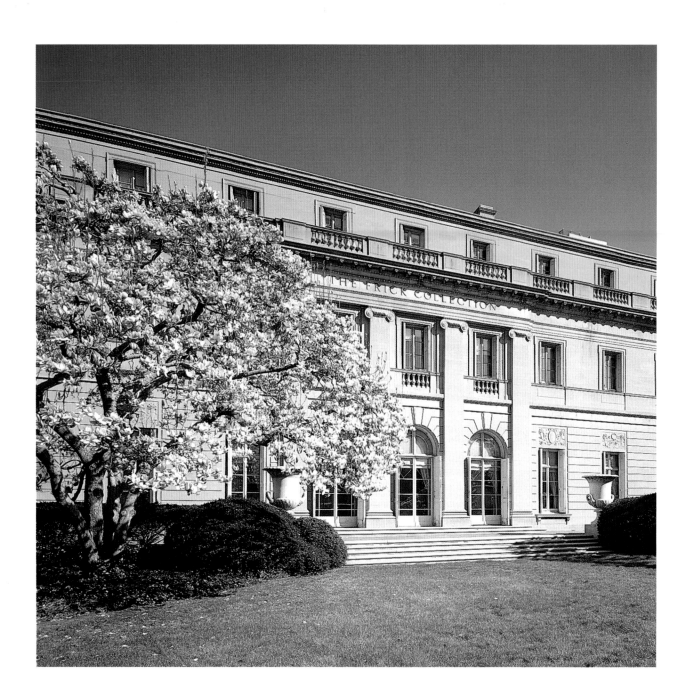

The Frick Collection / A Tour

Edgar Munhall,
with Susan Grace Galassi, Ashley Thomas,
and the Acoustiguide Corporation staff

SCALA

The Frick Collection, New York,
in association with Scala Publishers, London

Copyright © 1998, 1999
The Frick Collection
and Acoustiguide Corporation

The Frick Collection
1 East Seventieth Street
New York, NY 10021

Acoustiguide Corporation
1301 Avenue of the Americas
Thirty-second Floor
New York, NY 10019

First published in 1999
by Scala Publishers Ltd
Northburgh House
10 Northburgh Street
London EC1V OAT

Reprinted with amendments 2004

Hardcover edition distributed
outside The Frick Collection
in the USA and Canada by
Antique Collectors' Club
Market Street Industrial Park
Wappingers' Falls, NY 12590

ISBN Museum Editon: 1 85759 229 8
ISBN Trade Editon: 1 85759 223 9
Library of Congress: 99–071401

All measurements are in inches
followed by centimeters;
height precedes width precedes depth.

Edited by Joseph Focarino
Designed by Nathan Garland
Produced by Scala Publishers Ltd
Printed and bound by Società Editoriale
Lloyd, Trieste, Italy

Photographs by Richard di Liberto;
special gallery photographs
by John Bigelow Taylor

Front cover illustration: Garden Court
Frontispiece: Fifth Avenue Façade
Back cover illustration: Entrance

Director's Introduction

This volume intends to serve visitors to The Frick Collection and non-visitors alike by presenting a "tour" as experienced by those who listen to the ArtPhone available on site. This random-access series of commentaries enhances the viewer's appreciation of many of the Collection's masterworks.

Heretofore, however, these texts have not been available in printed form. We imagine that many will benefit from either the souvenir aspect of this book or from the ability to "listen" to commentaries not heard owing to a shortage of time or stamina (there being one hundred possible stops on the tour).

Presented here are the same texts recorded for the Acoustiguide INFORM® Audio Tour of The Frick Collection, known as ArtPhone, a product of the Acoustiguide Corporation, in cooperation with whom this book was produced. ArtPhone was introduced at The Frick Collection in 1998. In situ, these tours are available in six languages (English, French, German, Italian, Japanese, and Spanish) and this volume, initially, in three. The texts are conversational in tone, by design, to facilitate the impression that one is wandering through the galleries on a very personal tour. The circled numbers appended to each text are those of the ArtPhone tour. They are intended for the hearing-impaired or visitors who choose to read the texts rather than listen to them in the galleries.

We are grateful to the following for their assistance: Joseph Focarino, editor; Nathan Garland, design; Richard di Liberto, photography; and John Bigelow Taylor, special gallery photography. Dan Giles of Scala Publishers Ltd has encouraged and overseen the production. Credit should also be given to the narrators whose voices make the tour unique. They include Yoshi Amao, Jacqueline Chambord, Susan Grace Galassi, Marco Grassi, Inmaculada de Hapsburgo, Nicholas Hall (with special credit to Rufus, Mr. Hall's dog), Francis du Maurier, Olga Merediz, Ursula Mitra, Edgar Munhall, Dietmar Post, Roger Pretto, Kioko Takita, Maria Kristina von Wittgenstein, and the undersigned.

For more information on the Collection, please consult our website at *www.frick.org* or our comprehensive publication *The Frick Collection: An Illustrated Catalogue*, vols. I–VIII (1968–92).

For technical reasons only, this, the Director's Introduction, has been changed from the recorded version.

Samuel Sachs II
Director, The Frick Collection

Hoffman
Portrait of Henry Clay Frick
Marble
H. 28 in. (71.1 cm); W. 23 in.
(58.4 cm); D. 14 in. (35.5 cm)
Signed and dated: MALVINA HOFFMAN /
FECIT 1922
Gift of Miss Helen C. Frick in 1935
Acc. No. 35.2.81

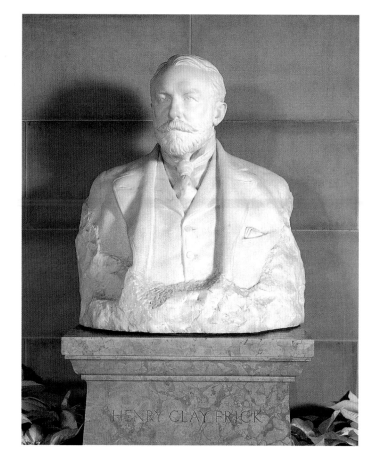

Malvina Hoffman (1887–1966)
*This New York sculptor studied in
Paris with Auguste Rodin after 1910.
In 1929 she received a commission
to sculpt 110 bronzes for the "Races
of Mankind" exhibition at the Field
Museum of Natural History in
Chicago, a project that allowed her
to travel extensively in Asia and Africa.
She was also well known for her
portrait busts of prominent American
figures and the architectural reliefs
she executed at the American Military
Cemetery and the University of
Pittsburgh.*

The sculptor Malvina Hoffman knew the subject of this marble bust well. She recalled that about a decade before she carved it, Mr. Frick had visited her studio to view a bust of his daughter that he had commissioned. In studying his face, Hoffman had been struck by how sympathetic and unhurried he had seemed. "I felt it inevitable," she noted, "that I would one day do his portrait."

Henry Clay Frick was one of the most powerful and creative industrialists of the nineteenth century. He was born in 1849 on a farm in southwestern Pennsylvania. By the age of thirty he had become a millionaire, as the leading supplier of coke to the growing steel industry of nearby Pittsburgh. His administrative skills impressed Andrew Carnegie, who invited him to become the manager of the vast Carnegie steel interests— the largest in the world. By 1900, the two men had fallen out. Mr. Frick, very rich with his settlement, could now turn to his private obsession— collecting great works of art—and establish his presence in New York City, along with his wife, Adelaide Howard Childs, and their two children.

Mr. Frick's interest in art was apparent very early on. His first recorded purchase—in 1881—was a landscape by a Pittsburgh artist. By the time of his death in 1919, Henry Clay Frick was regarded as one of the most discriminating collectors of all time. Though he consulted scholars, dealers, and other collectors, he ultimately relied on his own taste.

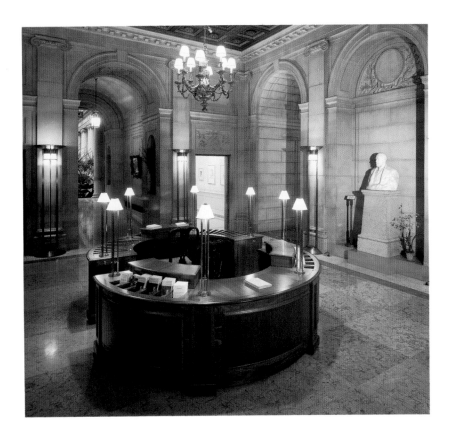

In 1911, Mr. Frick purchased the property along Fifth Avenue between Seventieth and Seventy-first Streets that became available when The Lenox Library, which then stood here, was incorporated in The New York Public Library. For the previous six years, he had been renting a former Vanderbilt residence at Fifth Avenue and Fifty-second Street.

The man Mr. Frick chose to design his house—Thomas Hastings— was one of America's leading architects at the time, a specialist in the classical style. His plans were completed by 1912; construction began the following spring, and the Fricks moved into their new house in November 1914. The cost of the property alone was $3,000,000, the construction of the house cost an additional $2,000,000, plus about $300,000 for the interior design. The cost of the works of art was yet another, astronomical figure. After all that, it's rather amusing to see the new Frick house described in the press as "a long bungalow-like residence with a fine picture gallery"!

Mr. Frick lived here only five years before his death in 1919. Mrs. Frick stayed on until 1931, when she died. At that point, the original house was transformed architecturally to function as a museum, following the designs of America's leading architect of *that* period—John Russell Pope. This Entrance Hall was created then, as well as the Garden Court, two galleries adjacent to it, and the Music Room.

The new Frick Collection first opened to the public on December 16, 1935.

Bastiani

Adoration of the Magi
Tempera, on panel
20 ½ × 11 in. (52 × 28 cm)
Painted probably in the 1470s
Acc. No. 35.1.130

Tiepolo

Perseus and Andromeda
Oil, on paper affixed to canvas
20 ⅜ × 16 in. (51.8 × 40.6 cm)
Painted probably in 1730
Acc. No. 18.1.114

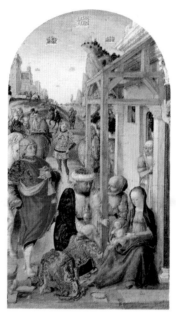 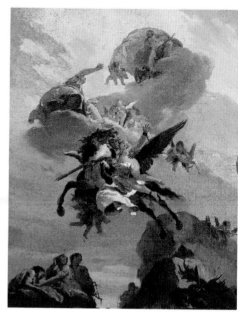

Lazzaro Bastiani (d.1512)
*Bastiani is first recorded painting
in Venice in 1449. His traditional style
was influenced by Andrea del Castagno
and Gentile Bellini, with whom he
collaborated on a project at the Scuola
Grande di San Marco in Venice.
Bastiani is said to have been the teacher
of Vittore Carpaccio.*

Giovanni Battista Tiepolo
(1696–1770)
*This Venetian studied with Gregorio
Lazzarini, but found his greatest
inspiration in the works of Veronese.
Tiepolo executed religious and mytho-
logical oil paintings and large-scale
decorative frescoes for churches, palaces,
and private villas in northern Italy.
He was also commissioned to paint
altarpieces and decorate palaces for royal
families in Germany and Spain.*

Facing each other in this area are two works by Venetian painters, executed
250 years apart. Here you see Lazzaro Bastiani's *Adoration of the Magi* of
about 1475, painted on panel in tempera—a medium in which colored pig-
ments are mixed with egg whites. With the golden aura and jewel-like
effects that characterized Venetian painting from the earliest days, it depicts
in vivid detail the arrival of the three kings, come to worship the newborn
Christ and to offer him precious gifts—one of which St. Joseph is about to
squirrel away. The adventures of their journey are shown in the dreamlike
landscape above. Angels accompany the Magi on a squadron of flying
saucers—the red seraphim gifted with love, and the blue cherubim gifted
with knowledge.

Another airborne drama is depicted on the opposite wall, with
Giovanni Battista Tiepolo's *Perseus and Andromeda*, a study for a ceiling fres-
co the artist painted in Milan around 1730, but which was destroyed by
bombing in 1943. Soaring through the buff-colored clouds on his winged
horse Pegasus, the hero Perseus grasps the princess Andromeda, whom he
has just unchained from the rock to which she had been attached and
freed from the snaggle-toothed monster who would have gobbled her up.
Minerva and Jupiter observe the drama from on high. With Tiepolo, as
this small sketch suggests, four centuries of continuous artistic excellence
in Venice conclude with glorious fireworks.

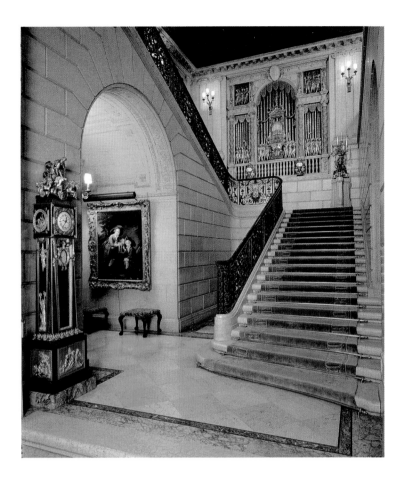

Thomas Hastings (1860–1929)
*Hastings studied at the École des
Beaux-Arts with Louis-Jules André
in 1884, beginning his career in the
New York firm of McKim, Mead &
White soon after. A few years later
he and his colleague John Merven
Carrère formed their own practice,
designing private and public buildings,
such as The New York Public Library,
in a refined, classical style.*

This would be a good place for you to pause in your examination of
works of art, and consider for a few moments how Mr. Frick, his architect,
and his interior designer planned your experience for you.

Before this building was erected in 1913–14, Henry Clay Frick may
have already been contemplating creating a museum out of his collection.
But if so, he did not inform his architect, Thomas Hastings, to whom
he simply said, "we want a small house with plenty of light and air and
land." To Sir Charles Allom, the brilliant interior designer he engaged to
create the major rooms of the first floor, he wrote: "We desire a comfort-
able, well arranged home, simple, in good taste, and not ostentatious."
Neither message hints at a future museum, nor prepares us for the reality
of the Frick house as it was actually built and decorated.

What makes this museum so unusual and appealing is just how
its original, residential character has been preserved, complementing and
augmenting your enjoyment of the works of art it contains—like a
sumptuous frame, a luxurious carpet, or a jewel casket. That atmosphere
results, first, from the architect's use of grand spaces, noble proportions,
and a restrained classical vocabulary of detail. Into that shell, Sir Charles
Allom introduced an eighteenth-century English style of interior, based
on precise historical precedents, that contrasted with the flamboyant
mishmash that had characterized New York residences of the very rich
in the previous generation.

Drouais

The Comte and Chevalier de Choiseul as Savoyards
Oil, on canvas
54 ⅞ × 42 in. (139.4 × 106.7 cm)
Signed and dated: *Drouais le fils / 1758*
Acc. No. 66.1.164

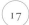

François-Hubert Drouais (1727–75)
*Of Norman extraction, Drouais lived
all of his life in and around Paris.
He began his artistic training under his
father, a miniaturist, and later studied
under Carle Vanloo, Charles Natoire,
and François Boucher. He received
his first royal commission in 1757 and
became a full member of the Academy
a year later. Drouais received great
acclaim for his portraits of members of
the court of Louis XV, foreign aristo-
crats, artists, and children.*

Looking out at us from the niche at the left of the stairs are two appealing boys whose gentle smiles and delicate gestures seem a little odd, considering their outlandish clothes and their rustic setting.

At first glance, you might suppose that the artist, François-Hubert Drouais, had painted here some picturesque urchins he encountered along a country road. But in fact, this was a commissioned portrait of the Comte and Chevalier de Choiseul, aged six and four, disguised as some picturesque urchins the artist might have encountered along a country road. They were cousins of the famous Duc de Choiseul, foreign minister under Louis XV.

Drouais dressed his subjects as Savoyards, the gypsy-like people from Savoy who wandered over France in floppy hats working at odd jobs and in street fairs in order to support the families they left at home. With this disguise, the artist was implying that these boys were models of filial devotion—a conceit that is strongly reinforced by the presence of the faithful dog, a King Charles spaniel. The tools of their trade—entertainment—include a hurdy-gurdy strapped over the boy at the left and a peep-show box, to which his brother points. The hanging strings would have changed the show inside the box.

If you look carefully, you will see that Drouais' models have not totally abandoned their distinguished social status: their disheveled garments are made of velvet, their buttons are of gold, and both boys have powdered hair.

Lieutaud, Berthoud, and Caffiéri

Longcase Regulator Clock
Oak, veneered with various woods,
mounted with gilt bronze
H. overall 100 in. (254 cm);
W. of marble plinth 23 ¾ in. (60.3 cm);
D. of plinth 14 ⅝ in. (37.2 cm)
Dated: *1767*
Acc. No. 15.5.46

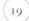

Balthazar Lieutaud (*d.*1780)
*Continuing his family's profession,
Lieutaud became a master* ébéniste *in
1749. He specialized in ornate
clockcases, which he often decorated
with bronze sculptures by Edme Roye,
Charles Gimpelle, and Philippe Caffiéri.*

Ferdinand Berthoud (1727–1807)
*Of Swiss birth, Berthoud went to Paris
in 1745 and may have entered the
studio of Julien Le Roy. Serving as*
horloger du roi *by 1773, Berthoud
was well known for his technical skills
and was an innovator in horological
research.*

Philippe Caffiéri (1714–74)
This bronzier *collaborated with his
father until the elder's death in 1755.
Moving away from his father's rococo
style, Caffiéri produced bronzes
to decorate early pieces of neoclassical
furniture. He also supplied altar
furniture for Notre Dame in Paris
(destroyed) and the cathedral at Bayeux.*

This sumptuous longcase clock was intended to be the instrument by which all other timepieces in a grand house were set. Its exceptional precision is due to the advanced movement concealed behind the enamel dial, which displays not only solar but Greenwich mean time, as well as the days and months of the year. The works, including an innovative pendulum alternating rods of steel and brass to counteract the effects of humidity and temperature, were crafted by Ferdinand Berthoud, one of the greatest clockmakers of eighteenth-century France. Balthazar Lieutaud, who specialized in clockcases, made the oak case, veneered in a variety of luxurious woods, and the splendid sculptural ornaments are by Philippe Caffiéri, bronzemaker to Louis XV. Such a clock would have been commissioned only for the court or the King himself.

The gilded motifs all relate to the passage of time. At the top is the god Apollo, driving the magnificent chariot of the sun on its daily journey across the heavens. Signs of the Zodiac encircle the dial, and at the clock's base the Four Seasons are represented in relief, with Spring and Summer together on the front. On the left side, the nymph Daphne is transformed into a laurel tree by her river god father, allowing her to escape Apollo's amorous pursuit. While on the far side—not visible from where you are standing—the maiden Clytie, who always faces the sun pining after Apollo, changes into a sunflower.

Vermeer
Officer and Laughing Girl
Oil, on canvas
19 ⅞ × 18 ⅛ in. (50.5 × 46 cm)
Painted between 1655 and 1660
Acc. No. 11.1.127

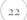

22

Johannes Vermeer (1632–75)
Vermeer lived most of his life in Delft,
where he joined the Guild of St. Luke
after 1653. Little is known about his
artistic training, but his paintings show
the influence of Carel Fabritius and
Utrecht's Caravaggesque painters. Only
thirty-five to forty paintings are thought
to have been painted by Vermeer.

In Mr. Frick's day, Rembrandt was the most highly regarded Dutch
Old Master. In our time, he has been supplanted by Vermeer. In place of
Rembrandt's bombastic splendor and unrestrained emotions, Vermeer
offered images of puritanical order and quiet harmony. Each age has its own
aesthetic needs, it seems.

The first small picture presents the familiar components of a classic
Vermeer: a man and a woman seen sharing a pleasant moment alone,
in a comfortable interior flooded with golden light and—you can almost
feel it—cool air. Whatever the nature of the human exchange depicted
here, it seems obvious that the real subject of the picture is light—
the intangible light shown bursting in through the open window, breaking
up reflections in the leaded panes, muffled through the curtains, caressing
the soft plaster wall, lingering sporadically on glowing fabrics, sparkling
glass, or the soft expanse of the vellum map (which depicts Holland, west
at the top). But the light soon recedes into dark corners and will soon
accent the young woman's beguiling face and soft kerchief differently.
In this subtle fashion, Vermeer makes light a metaphor for time, and
reminds us ever so gently of its inevitable consequences. Fortunate are we
to have been permitted to eavesdrop on this golden moment.

A few feet to your right hangs another work by Vermeer—the *Girl
Interrupted at Her Music*—acquired by Mr. Frick in 1901. It was his first work
by this artist, once called "the Sphinx of Delft."

Goya

Don Pedro, Duque de Osuna
Oil, on canvas
44 ½ × 32 ¾ in. (113 × 83.2 cm)
Signed: *Por Goya*
Painted probably in the 1790s
Acc. No. 43.1.151

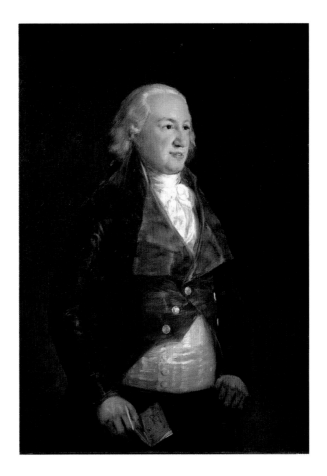

Francisco de Goya y Lucientes
(1746–1828)
Born in Fuendetodos, Goya trained first in Saragossa and then in Madrid with Francisco Bayeu. After working in Italy in 1771, he became a designer at the Royal Tapestry Factory in Madrid in 1774. Two years later he was appointed court painter to Charles III and maintained this position under the King's successors, Charles IV and Ferdinand VII. In addition to painting, Goya was also skilled as a draftsman and printmaker whose subjects range from portraits to religious paintings to satires. The artist fell out of favor with the Spanish court and moved in 1824 to Bordeaux, where he died.

Don Pedro, ninth Duke of Osuna, was one of Francisco Goya's most important patrons. Only the royal court itself ordered more works from the great Spanish artist than this distinguished nobleman, who commissioned more than twenty-four paintings for his country palace outside Madrid.

Don Pedro was Lieutenant General of the Armies and ambassador to the Viennese court. As a patron of the arts and letters, he was appointed to the Royal Spanish Academy, and in 1795 Charles IV conferred on him the coveted Order of the Golden Fleece. But he does not wear this decoration in his portrait—perhaps Goya made the picture slightly earlier, or maybe the Duke wanted to stress the intimacy and informality so evident here. Dressed simply but elegantly, he stands against a dark empty background, suggesting night. His ruddy face is benign and sympathetic, his lips parted as if he were speaking. It's not hard to imagine what made him so popular with the intelligentsia of his day. The piece of paper he clutches reads, "The Duke of Osuna, by Goya," bringing this congenial sitter and his artist friend together.

Boucher

Madame Boucher

Oil, on canvas

22 ½ × 26 ⅞ in. (57.2 × 68.3 cm)

Signed and dated: *f. boucher. 1743;*

signed again: *ʃ Bouche*[r]

Acc. No. 37.1.139

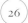

François Boucher (1703–70)
In 1720 Boucher studied briefly with
François Le Moyne, thereafter joining
the workshop of Jean-François Cars.
He won the Prix de Rome in 1723 and
four years later embarked on a long
visit to Italy. Elected to the Academy
in 1734, Boucher gained fame as a
painter, draftsman, and book illustrator,
and held positions in the Beauvais
and Gobelins tapestry factories. He was
appointed premier peintre *to Louis*
XV at the age of sixty-two and enjoyed
the influential patronage of Madame
de Pompadour.

After years of posing for her husband as various goddesses and sea nymphs, Marie-Jeanne Buseau finally got a chance here to pose as herself: the twenty-seven-year-old wife of a famous court painter and the mother of three children. Propped up with a pillow, she stretches out across a chaise longue as though she had just awakened from a nap. The jumble of details around her—a book with its red marker, an open letter, the sewing bag hanging from the key of an opened drawer, a rumpled scarf lying around it, the ball of yarn that has rolled across the floor—suggests she might not have been much of a housekeeper. But the gold watch and fob hanging on the wall suggest she didn't need to do such work.

The apartment in which her husband painted her was very stylish, as only a Parisian apartment can be. See how the brocade-covered wall precisely matches the tawny coloring of the drapery cascading down at the right, and how it sets off the brilliant tones of the screen edged in red lacquer. On the shelves of the lacquered cabinet are a porcelain figurine and a tea service that reflect the artist's taste for Asian bric-à-brac so fashionable in Paris when this portrait was painted—1743.

In its composition, this picture parodies the classical Renaissance depictions of the reclining Venus by Giorgione and Titian. For this reason it has been called "Boucher's Untidy Venus."

Riesener
*Secrétaire with Pictorial
and Trellis Marquetry*
Oak, veneered with marquetry of various
woods, mounted with gilt bronze
H. 56 ⅜ in. (143.2 cm); W. 45 ½ in.
(115.5 cm); D. 17 ¼ in. (43.8 cm)
Signed and dated: *Riesener. fe 1790*
Made in the mid 1780s; remodeled by
Riesener in 1790
Acc. No. 15.5.75

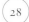

Jean-Henri Riesener (1734–1806)
*Riesener was born in Westphalia and
moved to Paris around 1755 to train
in the workshop of Jean-François
Oeben. Ébéniste du roi after 1774,
Riesener produced gilded and ornately
detailed furniture for Louis XVI,
Marie-Antoinette, and other members
of the royal family until the fall of
the monarchy. After the Revolution,
Riesener was unable to sustain his
popularity as a cabinetmaker and retired
in 1800.*

In the 1780s, Queen Marie-Antoinette commissioned this tall, upright secretary and the matching chest a few steps to the left from Jean-Henri Riesener, the greatest cabinetmaker during the reign of Louis XVI. They are considered among his masterpieces, and are two of the most important pieces of furniture in The Frick Collection.

In 1790 and 1791, Riesener remodeled the gilt-bronze mounts to give them a less ornate appearance, probably for the Tuileries, where the royal family was forced to move at the start of the French Revolution. Mobs stormed this palace on August 10, 1792. Perhaps those rampaging crowds smashed the chest's original top, which has since been replaced. During the next three years, the pieces were moved around in temporary storage, but by then the monarchy had been abolished, and Marie-Antoinette had lost her head to the guillotine.

Both pieces are full of wonderful illusions, created with a veneer of variously colored woods—a technique known as marquetry. Look carefully at the front of either one and you'll see panels on both sides that look like trelliswork containing stylized flowers—a pattern much favored by the Queen. These panels appear to pass behind the central panel with its elaborate depiction of flowers, fruit, and vines. And on top of that panel is a gilded oval plaque that seems to hang from a ribbon hooked over the keyhole. The plaque is adorned with amorous doves, a quiver of Cupid's arrows beneath them. This traditional motif, suggesting love, was enormously popular in the eighteenth century.

Renoir
Mother and Children
Oil, on canvas
67 × 42 ⅝ in. (170.2 × 108.3 cm)
Signed: *Renoir*
Painted probably about 1875–6
Acc. No. 14.1.100

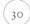

Pierre-Auguste Renoir (1841–1919)
*Renoir was born in Limoges, but
moved to Paris at the age of four.
He began his training as apprentice
to a painter of porcelains, finally
entering the École des Beaux-Arts
at twenty-one. He first exhibited at the
Salon of 1864 and was one of the
organizers of and participants in
the first Impressionist exhibition of
1874. He traveled frequently after 1881,
even visiting Algeria, before he died
in Cagnes-sur-Mer at the age of
seventy-eight.*

The unusual scale of this Impressionist picture would suggest that it was one of the society portraits Renoir was painting on commission in his early years, but evidence indicates that in this case, the artist hired professional models to pose. Furthermore, when the artist exhibited the work at the second Impressionist exhibition in 1876, he entitled it simply *A Promenade*.

This has long been one of the most popular paintings in The Frick Collection, and no wonder! Who could resist the appeal of these perfectly behaved, perfectly groomed, chic little girls in their fur-trimmed outfits being gently eased forward by their mother or nanny as though they were about to greet someone? The cool palette dominated by blues, greens, and lavender conveys the feel of early spring, before the bulbs have popped, and when a white fox muff would be comforting as well as pretty. Renoir employed a variety of painterly manners on this canvas—from the highly finished to the softly blurred. He must have smiled, though, as he painted the doll, for its frankly primitive rendering makes it look as though its bearer had painted it herself.

The Impressionist exhibition at which this picture first appeared was described ferociously by one critic as "a cruel spectacle of works by lunatics," though another may have had a point when he said, "Renoir's portraits are remarkable for their eyes, which seem to jump off the canvas."

Laurana

Bust of a Lady

Marble

H. 18 ¾ in. (46.6 cm); W. 18 in.
(45.8 cm); D. 9 ⅜ in. (23.9 cm)

Made in the 1470s

Acc. No. 16.2.1

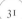

Francesco Laurana (*c.*1430–*c.*1502)
*Laurana was born probably in Vrana
around 1430. He was recorded working
in Naples after 1453, and then between
1461 and 1466 in Provence, where
he produced sculpture and medals at the
court of Anjou. Laurana probably
worked in Sicily around 1468 to 1471,
and divided his later years between
Naples and France. He is best known
for his female portrait busts.*

The two works of art displayed in this tiny gallery called the Octagon were executed some thirty years apart, in the second half of the fifteenth century.

Here, in the earlier work, the Carmelite monk-artist Fra Filippo Lippi has depicted the drama of the Virgin Mary's miraculous conception as announced to her by the angel Gabriel. While the two sacred figures appear to interact as in a formal dance, the shadow behind the Virgin lends a startling sense of reality to their meeting. It also conveys in a literal way the significance of the angel's message: "The Holy Spirit will come upon you, and the power of the Most High will overshadow you."

Across the room stands what is almost a three-dimensional equivalent to one of Lippi's painted heads—a portrait of an unknown lady carved in marble by Francesco Laurana in the late 1470s. When this bust was dredged up from the harbor at Marseilles in the early eighteenth century— the nose already broken—it was believed to date from Roman times and to represent the Empress Agrippina. It was not until 1914 that it was linked with other idealized portraits by the elusive Laurana. Specifically, it resembles two others by him also set upon bases decorated with narrative reliefs, whose significance has never been satisfactorily explained. Like them too, it exhibits the familiar hallmarks of Laurana's highly individual style: an assemblage of smoothly flowing surfaces and shapes refined to near-abstraction.

Lippi

The Annunciation
Tempera, on two panels
25 ⅛ × 19 ⅞ in. (63.8 × 50.5 cm)
Painted about 1440
Acc. No. 24.1.85

Fra Filippo Lippi (*c.* 1406–69)
Not much is known about the artistic
training of this Florentine, who took
the monastic vows of a Carmelite monk
around the age of fifteen. Although
it is difficult to reconstruct his early
years, documents show that after 1430
Filippo received commissions for frescoes
and devotional panel paintings from
local churches, the Medici, and other
powerful patrons in Florence, Padua,
Prato, and Spoleto.

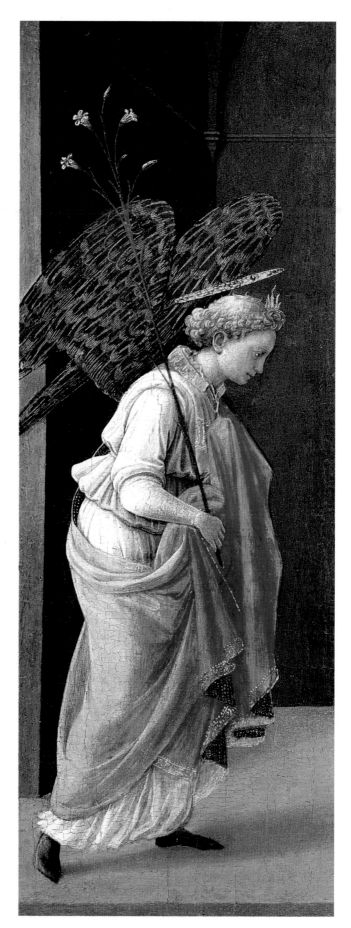

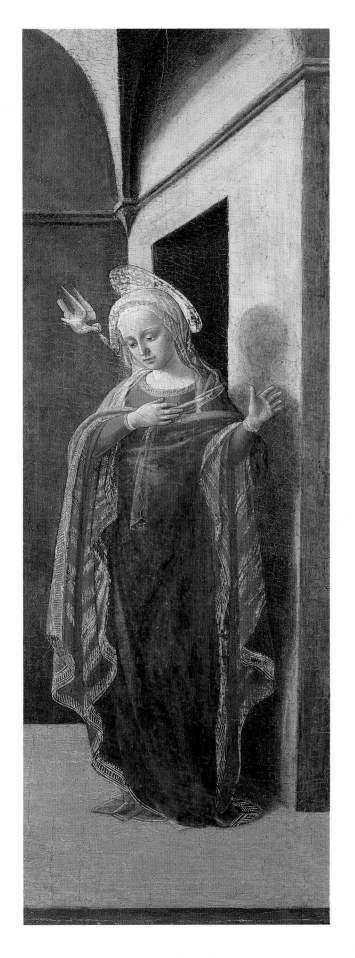

Memling
Portrait of a Man
Oil, on panel
13 ⅛ × 9 ⅛ in. (33.5 × 23.2 cm)
Painted about 1470
Acc. No. 68.1.169

42

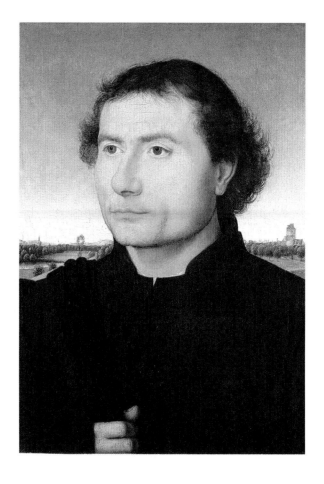

Hans Memling (1430/40–94)
*This German artist's style suggests
he trained with Rogier van der Weyden
in Brussels before becoming a citizen
of Bruges in 1465. Memling painted
portraits and altarpieces for local
churches, wealthy Flemish burghers,
and foreign bankers or merchants living
in the Netherlands.*

We don't know who this sitter was—the plain coat and cloak flung over his shoulder give no clues as to his nationality, occupation, or rank. But Hans Memling, whose portraits were much admired in the late fifteenth century—in Italy as well as his native Northern Europe—has captured not only the likeness but the character of this unknown man.

Although Memling placed the sitter so close to us that he seems pressed against the frame, he seems psychologically remote, absorbed in his own thoughts. In his firmly modeled face and serious expression, we sense not only a strong individual, but a man of intelligence and spirituality.

The bust-length presentation of a figure in front of an open window, with a landscape beyond, became a formula in Flemish painting, and this one dating from about 1470 is probably one of Memling's earliest known works in this format. The serene and impeccably crafted setting evokes a wonderful peace of mind. But what makes the picture so magical is the transition in the sky—from cloudless blue, to a very pale blue, to almost white at the horizon.

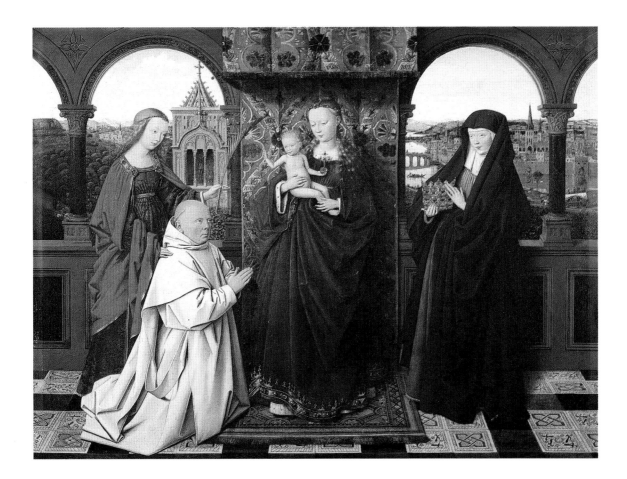

Van Eyck
*Virgin and Child,
with Saints and Donor*
Oil, on panel
18 ⅝ × 24 ⅛ in. (47.3 × 61.3 cm)
Painted about 1441–3
Acc. No. 54.1.161

Jan van Eyck (active 1422–41)
*Van Eyck was born probably in the
province of Limburg, and is first
mentioned as an artist in the employ
of the Count of Holland at The Hague
between 1422 and 1424. He was
appointed court painter and* valet de
chambre *to Philip the Good, Duke
of Burgundy, in 1425. Van Eyck
established himself around 1430 in
Bruges, where he continued to paint for
the Duke as well as undertaking private
commissions.*

Jan van Eyck, the early Renaissance Flemish master who created this painting, may not have invented the technique of oil painting, as people used to claim, but he certainly brought it to a degree of perfection that is still amazing today.

Here, he has depicted assembled in an airy loggia a fantastic assemblage of characters: the Virgin and Child under a canopy inscribed "Hail, Mary, full of grace," flanked on the right by St. Elizabeth of Hungary, holding the crown she gave up to become a nun; to the left, St. Barbara with the tower behind her in which she had been imprisoned; and, solemnly kneeling, the Carthusian monk Jan Vos, who commissioned the painting.

No clear explanation has been found for the presence of these two saints. Elizabeth may have been included because she was the patron saint of the Duchess of Burgundy, who made donations to Carthusian monasteries such as the one Jan Vos was associated with. Barbara was the patron saint of soldiers, which may explain the statue of Mars visible in a window of her tower. Probably both saints had some particular association with Jan Vos' monastery, the Charterhouse of Genadedal, near Bruges.

Documents indicate that Vos commissioned this painting in 1441, the year of van Eyck's death, and that it was dedicated two years later. For this reason, it is believed van Eyck began the painting—particularly the central portion—but that the rest was completed after the artist's death by assistants in his studio.

Multscher
Reliquary Bust of a Female Saint
Bronze
H. 12 ⅝: in. (32 cm)
Made perhaps in the 1460s
Acc. No. 16.2.59

48

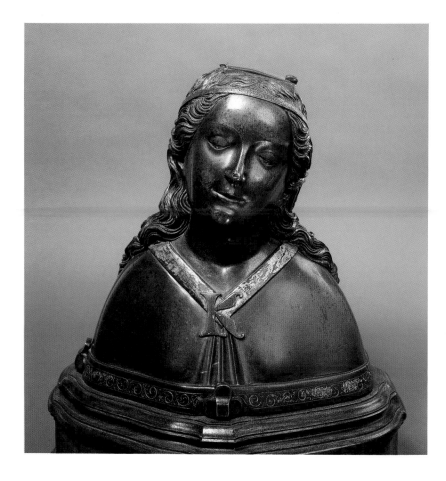

Hans Multscher (c. 1400–67)
*By 1427 Multscher was working as
a sculptor and painter in Ulm, where he
later supervised a large workshop that
produced altarpieces. His extensive
travels to France and the Netherlands
greatly influenced both his painting
and his sculpture. Apart from the
Frick bronze bust, most of this artist's
sculpture was executed in wood or stone.*

The first question visitors often ask here is, Why does this small female bust have a hole on top of her head? In fact, this type of sculpture is not just a work of art, but a devotional object, made to contain the holy relics of a saint—a tooth or piece of bone or other fragment of the body believed to possess miraculous powers. Worshippers would kneel before the reliquary and pray. The hole was probably once covered with a piece of crystal.

The bust is attributed to Hans Multscher, an influential fifteenth-century German artist whose fame spread throughout Northern Europe. The grace and imagination of his work are evident in the gentle tilt of the head, the luxuriant flow of curls, and the delicate line at the corners of each eye.

The "K" fastened to the gilded collar suggests that the bust once contained relics of Katherine of Alexandria. This learned fourth-century noblewoman who dreamed she became the bride of Christ is the patron saint of education and learning.

Witz, circle of
Pietà
Tempera and oil (?), on panel
13 ⅛ × 17 ½ in. (33.3 × 44.4 cm)
Painted about 1440
Acc. No. 81.1.172

**French,
probably South of France**
Pietà with Donor
Tempera or mixed technique, on panel
15 ⅝ × 22 in. (39.7 × 55.8 cm)
Painted in the mid fifteenth century
Acc. No. 07.1.56

51

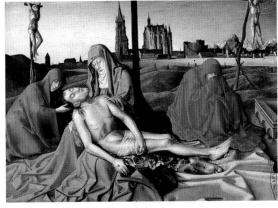

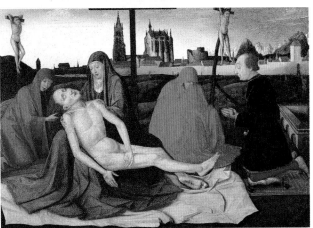

Konrad Witz (*c.* 1400/10–45/46)
*Born in Rottweil, Witz was document-
ed as a member of the Basel painters'
guild in 1434. Although his style
reflects the naturalism of Jan van Eyck
and the Master of Flémalle, it is not
certain whether Witz trained in the
Netherlands or Burgundy. Unlike
his German and Netherlandish contem-
poraries who created rich and detailed oil
compositions, Witz painted primarily
in tempera.*

Mr. Frick bought the small *Pietà* to the right in 1907, believing it to be a
work by the Italian artist Antonello da Messina. It was an unusual acquisition
because these so-called Primitives were very rare in American collections at
the time. It depicts the Virgin holding her dead son, with the two Marys
on either side. The thieves crucified with Christ still hang from their crosses,
and a donor in contemporary dress kneels at the far right. In the back-
ground is an extraordinarily vivid landscape—barren fields with a few tiny
figures wandering through them, and a Gothic walled town with a church
that looks much like the unfinished cathedral of Cologne as it appeared
in the fifteenth century, with snow-capped mountains in the background.
In fact, it's meant to represent Jerusalem.

In the early 1920s, Mr. Frick's daughter Helen purchased the painting
to the left, on the other side of the window—struck by its very close
resemblance to the picture we've been looking at. Art historians determined
that *this* is, in fact, the original version of the painting, and that her father
had purchased a copy, one made probably by an itinerant artist in southern
France who had seen this picture.

Attributed to a follower of the Swiss artist Konrad Witz, this *Pietà*
is frankly a much more beautiful and moving depiction of this piteous subject,
this time without a donor. It's better preserved, the color is richer, and the
light colder. And just look at the wonderful drapery—especially where
it covers Christ's loins. The details here are more vivid and appalling—such as
the slashed bodies of the hanging thieves. And that seated figure in orange
on the right, with her mysteriously shrouded head and the little dots of
tears on her cheek, is one of the most haunting figures in the whole history
of painting.

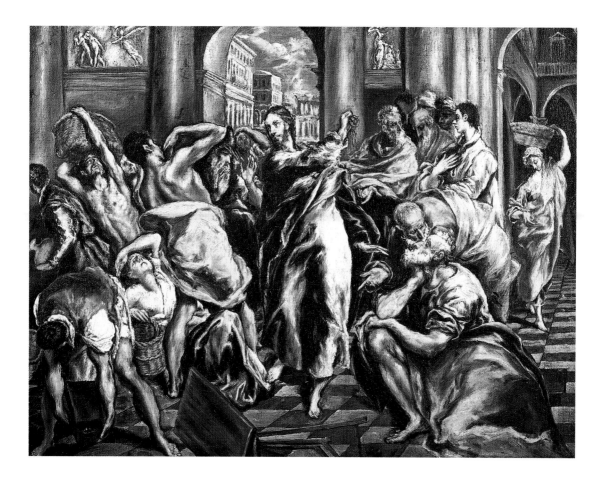

El Greco
The Purification of the Temple
Oil, on canvas
16 × 20 in. (41.9 × 52.4 cm)
Painted about 1600
Acc. No. 09.1.66

54

El Greco (Doménikos
Theotokópoulos) (1541–1614)
*El Greco was born in Crete, then a
Venetian dependency. It is supposed
that he trained as a youth with Titian
in Venice and was called to Rome
around 1570 to work for Cardinal
Alessandro Farnese. By 1577, El
Greco had settled in Toledo, where
he continued to paint portraits and
religious subjects for the remaining
years of his life.*

The theme of the Purification of the Temple absorbed the great master
El Greco throughout his career. Here, he depicts this passage from
the Book of Matthew: "Jesus went into the temple of God, and cast
out all of them that sold and bought in the temple, and overthrew the tables
of the moneychangers, and the seats of them that sold doves." During the
Counter Reformation, this was a popular subject, symbolizing the cleansing
of heresy from the Catholic Church.

El Greco fills the picture with his characteristic elongated figures
and daring colors—wine-red against acid yellow, oranges and greens
juxtaposed. This cold but brilliant palette, along with the rough brushwork
and explosive composition, generates remarkable dramatic intensity.

Christ strides forward in the center of the painting. To the left are
the frightened sinners, the violence of their turmoil underscored by the
broken table in the foreground. Directly above them, a sculpted relief
shows Adam and Eve being expelled from Paradise. To the right of Christ,
believers quietly discuss the chaotic scene. The Sacrifice of Isaac above
them is a reminder of the Crucifixion.

When Mr. Frick bought this painting in 1909, there were very
few El Grecos in American collections: the artist had only recently been
rediscovered, after falling into almost total obscurity. But Mr. Frick
owned three El Grecos, and this one must have meant a great deal to him,
for he hung it in his study on the second floor.

Bruegel

The Three Soldiers

Oil, on panel

8 × 7 in. (20.3 × 17.8 cm)

Signed and dated: BRVEGEL M.D[L?]XVIII

Acc. No. 65.1.163

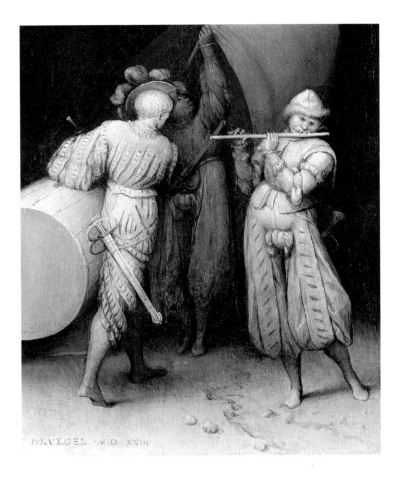

Pieter Bruegel the Elder

(*c.* 1525/30–69)

Although little is known about his early life, Bruegel is presumed to have studied with Pieter Coeck van Aelst and then with the print publisher Hieronymus Cock in Antwerp, before he entered the city's painters' guild around 1551. Bruegel moved to Brussels in 1563, where he painted landscapes and peasant scenes for private patrons and the city government.

The name of the Flemish artist Pieter Bruegel the Elder is familiar to all because of his colorful scenes of carousing peasants and his poetic landscapes. But this little panel belongs to a very special group of paintings he executed in muted tones of gray and brown. They are called *grisailles*, and the only other two known represent religious subjects. They were all probably intended as models for printmakers. Because of its rarity and haunting mystery, it should come as no surprise to learn that the Frick painting once belonged to King Charles I of England, a very discerning collector and art patron.

These mercenary foot soldiers, outlandishly dressed, were a common sight in sixteenth-century Europe, as they made music and twirled their banners in the streets like majorettes. The closest modern equivalent would be the tattoo of the Scottish Black Watch. Called *Landsknechte*, they were the inspiration for popular printmakers, as well as such artists as Dürer. But unlike them, Bruegel has caught a minor chord to the soldiers' sound, as though it were a preamble to the less attractive realities of war that follow invisibly behind them.

This room was originally installed on the second floor of the Frick house as the boudoir, or sitting room, of Mrs. Frick, whose portrait by Elizabeth Schoumatoff stands on the table before you. After Mrs. Frick's death in 1931, the wall panels and furnishings were moved down to their present location, and the room appears today much as it did in her time, although real eighteenth-century chairs and canapés have replaced the modern imitations that Mrs. Frick utilized. Now it is truly a French "period room"—in the sense that most everything in it, including the fireplace and the floor, was created in eighteenth-century France. The major exception is the extraordinary silk rug, which was woven in India in the sixteenth century during the reign of the Emperor Shah Jahan, builder of the Taj Mahal.

This intimate chamber was designed around the eight canvases painted by François Boucher in the early 1750s for his patron the Marquise de Pompadour, mistress of Louis XV. To complement these paintings, the American interior designer Elsie de Wolfe acquired for Mrs. Frick two great pieces of furniture: the central mahogany writing table by Riesener, and the bed table by Carlin to the right of the fireplace, as well as other attractive examples of the decorative arts. The various porcelains displayed in this room are all products of Sèvres, the French royal manufactory. Louis XV owned the factory and, with Madame de Pompadour, took delight in its luxurious creations.

Boucher

The Arts and Sciences

Oil, on canvas
H. 85 ½ in. (217.2 cm); W. either
30 ½ in. or 38 in. (77.5 or 96.5 cm)
Painted probably between 1750 and 1752
Acc. No. 16.1.4–11

 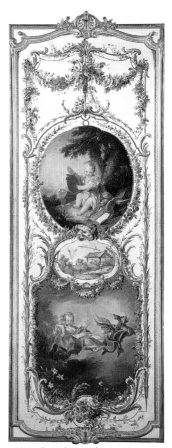

Architecture and Chemistry *Comedy and Tragedy*

The canvases of *The Arts and Sciences* by François Boucher that are installed around this room originally decorated an octagonal library in Madame de Pompadour's Château de Crécy near Chartres—a property (now destroyed) she acquired soon after becoming Louis XV's mistress in 1745. Before serving as wall decorations, Boucher's compositions had first been used as designs for chair backs and seats—as their shapes suggest. The artist was probably making good use of some stock at hand when Madame de Pompadour's decorative commission came along.

The idea of depicting children mimicking the activities of grownups was popular in mid-eighteenth-century France, but no artist had more fun with it than Boucher. Just observe the exploding chemistry experiment to the left of the fireplace, or the deadly serious "Medea" flying by on her dragon chariot to the right of the fireplace, or the boy looking through the wrong end of the telescope in the farthest panel on the right wall.

The various subjects Boucher treated here include, behind you, *Singing and Dancing*, and *Painting and Sculpture*, then, continuing on the adjacent wall, *Fowling and Horticulture*, *Fishing and Hunting*, and next to the mirror, *Architecture and Chemistry*, *Comedy and Tragedy*, then finally, *Astronomy and Hydraulics*, and *Poetry and Music*. Almost every theme can be interpreted as an allusion to some aspect of Madame de Pompadour's patronage of the arts and sciences.

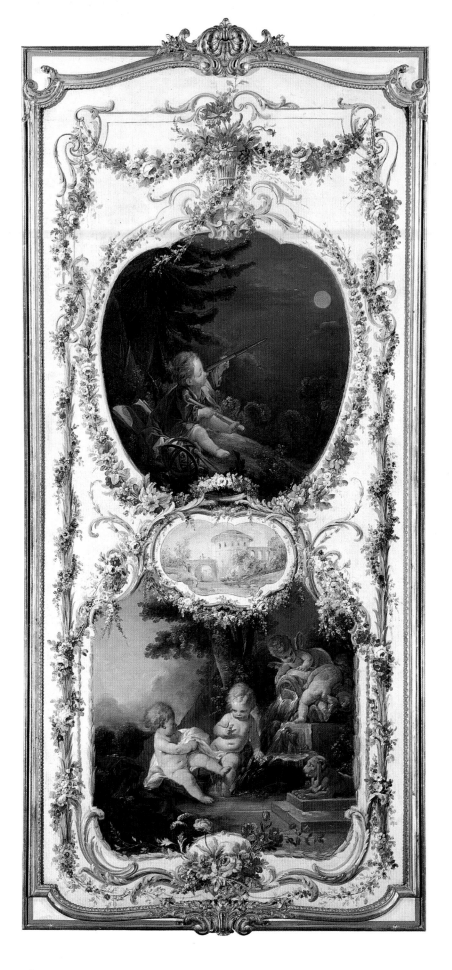

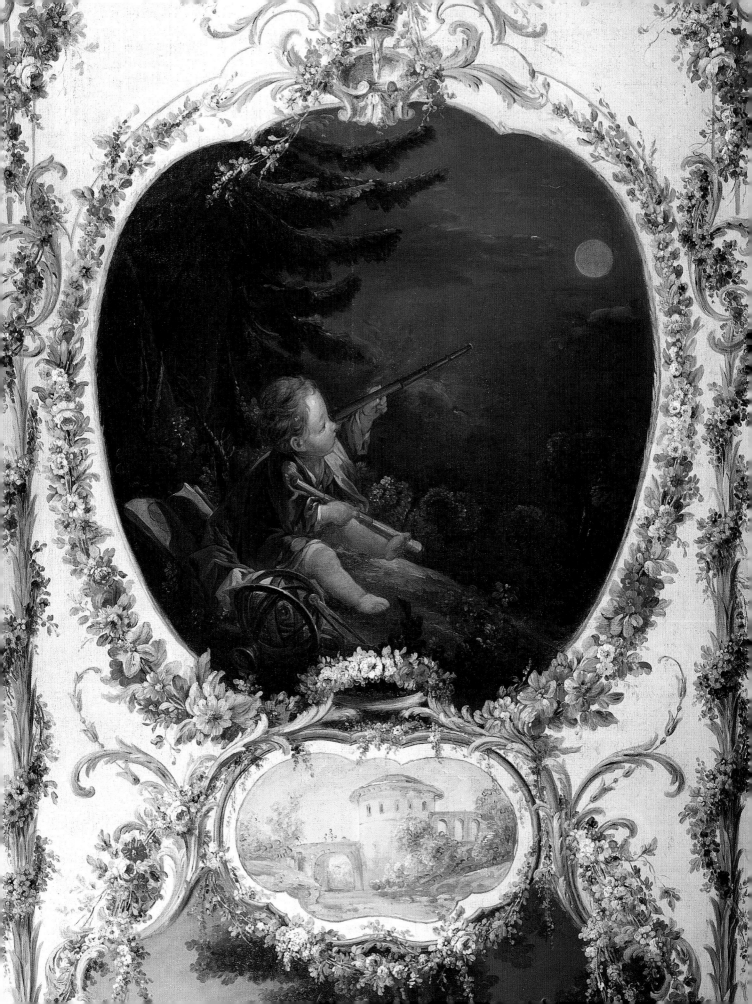

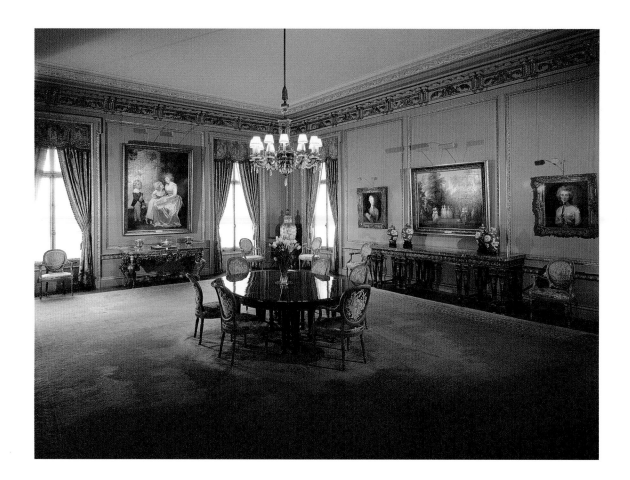

Dining Room

If one needed proof that the Frick residence was actually lived in and enjoyed by its owner, this Dining Room provides it. Of noble proportions and of a style that recalls state dining-rooms in English country houses of the eighteenth century, it was an appropriate setting for the formal dinners that Mr. Frick gave, at a rate of two per week, from October through May—usually for twenty-six guests.

Because the furniture in this room was actually to be used, rather than just admired, as in other rooms of the house, it was modern. Mr. Frick's interior designer, Sir Charles Allom, based its designs on English models of the eighteenth century, ranging from William Kent to Robert Adam. The central mahogany table, the chairs, and the four consoles were all Sir Charles's creations. The English silver wine coolers on them, Paul De Lamerie's silver-gilt écuelle under the portrait of the *Countess of Warwick*, the mantelpiece and the French clock and mounted Oriental vases that stand upon it, and the various Chinese porcelain vases around the Dining Room, however, are all originals from the eighteenth and nineteenth centuries.

Not surprisingly, Mr. Frick's chef—Joseph Donon—was internationally famous. Though he permanently left Mr. Frick's employ to serve his native France in World War I, he set a standard of culinary excellence that was always maintained here. From the basement kitchen, food was sent up by a dumbwaiter to the adjoining butler's pantry. A typical menu included caviar, terrapin, sweetbreads sautéed with mushrooms, roast partridge, orchid salad, and strawberry tarts.

Hogarth
Miss Mary Edwards
Oil, on canvas
49 ¾ × 39 ⅞ in. (126.4 × 101.3 cm)
Signed and dated: *W. Hogarth 1742*
Acc. No. 14.1.75

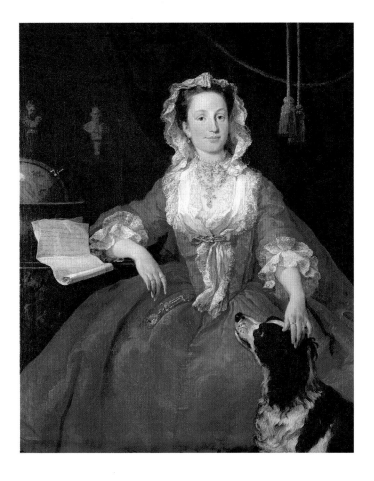

William Hogarth (1697–1764)
Hogarth was born in London, began working as apprentice to a silver-plate engraver at the age of fifteen, and later studied drawing with Thornhill. He is best known for his portraits and his satirical prints, most of which were based on his oil paintings of the same subjects.

Who was this English woman portrayed in such barbaric magnificence here? She seems an odd companion to the languid and so-refined ladies painted by Gainsborough, Hoppner, and Romney whose images adorn this room.

Miss Mary Edwards had inherited at the age of twenty-four—fifteen years before Hogarth painted her—the vast wealth of her father and was rumored to be the greatest heiress in England. Suitors were soon by her side, and she unfortunately chose one of the worst to be her husband, a Scots guardsman named Lord Anne Hamilton. Before long, he was squandering her money at gaming tables and transferring stock from her holdings to his. Acting swiftly in self-defense, Mary had the records of her marriage destroyed and her child declared a bastard—an extraordinary act, but one which saved her fortune, if not her reputation.

Hogarth decided to portray his unusual subject like a Byzantine Empress: posed in frontal hierarchy, wearing a scarlet damask gown, adorned with fabulous jewels and expensive Flemish lace, but caressing with carefree ease one of the greatest dogs in the history of art. At her right elbow unfolds a document carefully inscribed with lines from Elizabeth I's speech to her troops as they set off to meet the Armada: "Do thou great Liberty inspire their Souls [and] make their lives in their possession happy, or their deaths glorious in thy just defense." With the bust of the same Queen behind her, and a globe by her side, Miss Mary Edwards appears in full command of her place in the world.

Reynolds
General John Burgoyne
Oil, on canvas
50 × 39 ⅞ in. (127 × 101.3 cm)
Painted probably in 1766
Acc. No. 43.1.149

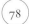

Sir Joshua Reynolds (1723–92)
Reynolds began his career as a portrait painter in Plymouth, after briefly serving as apprentice to Thomas Hudson in London. He made a three-year trip to Italy in 1749, settling in London after his return. He was elected the first president of the Royal Academy in 1768, and his Discourses had a significant impact on the development of British aesthetic theory.

General John Burgoyne became the toast of London after his victorious 1762 Portuguese campaign in the Seven Years War. During the heady decade that followed, Burgoyne served in Parliament, acted in amateur theatricals, gambled a lot, and wrote several plays. He also cultivated the friendship of Sir Joshua Reynolds, first president of the Royal Academy and London's most fashionable portraitist.

Burgoyne's senior officer during the Portuguese campaign may have commissioned this commanding portrait to commemorate their shared success. Here, in what would become a staple of Romantic portraiture, Burgoyne's dashing military figure stands silhouetted against a dramatic cloudy sky. He wears the brilliant red uniform of the Sixteenth Light Dragoons, one hand resting with authority on his sword, the other clasping his elegant plumed hat. In the distance, along the very low horizon, an actual battle rages—you can make out a tiny cannon in the corner and lines of redcoats marching forward, just as we've seen them in countless movies.

Burgoyne was sent to America three times during the Revolution. On his final posting, he was in charge of all British forces in the north. He triumphed at Ticonderoga, but history books emphasize his best-known role—as the British commander who surrendered to American troops at Saratoga in 1777.

De Lamerie
Écuelle
Silver gilt
H. 6 ¾ in. (17.2 cm); L. 9 ¾ in.
(24.8 cm); D. 6 ¹/₁₆ in. (15.4 cm)
Dated for 1739/40
Acc. No. 16.7.2

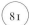

Paul De Lamerie (1688–1751)
The son of Huguenot parents,
De Lamerie was baptized in the
Netherlands and grew up in London,
where he was apprenticed to the
silversmith Paul Platel in 1703. Ten
years later, he registered the first of his
five maker's marks and set up a large
workshop in Windmill Street. One
of the first English silversmiths to work
in the rococo style, he produced ornate
works for George II, members of
the British aristocracy, and Russia's
imperial court.

The little trussed game bird on the lid of this lavish dish indicates the kind of stew that might have been served from it, enhanced by vegetables and herbs like the ones that spill over the molded edge. Such lavish French imagery became part of the English repertoire when Huguenot silversmiths such as Paul De Lamerie fled France in the late seventeenth century to escape persecution.

De Lamerie, the most celebrated of these émigrés, made this elegant écuelle—a type of small covered serving dish rare in English silver, and possibly unique in De Lamerie's own production. Its rich profusion of natural forms exemplifies his adaptation of the French rococo style. The pierced ladle fits snugly through the notch in the right side of the cover. The plate underneath was made over fifty years later by a London silversmith who imitated his celebrated French predecessor.

All three pieces are silver, coated with a thin layer of gold—a technique used since ancient times to prevent tarnishing and add to the richness of the metal.

Mr. Frick bought the écuelle in 1916, but we've displayed it only for the last few years. Plexiglass cases for security purposes were not, after all, part of Mr. Frick's original scheme. But then we thought: why keep something so beautiful hidden from view?

Gainsborough

The Mall in St. James's Park
Oil, on canvas
47 ½ × 57 ⅞ in. (120.6 × 147 cm)
Painted probably in 1783
Acc. No. 16.1.62

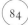

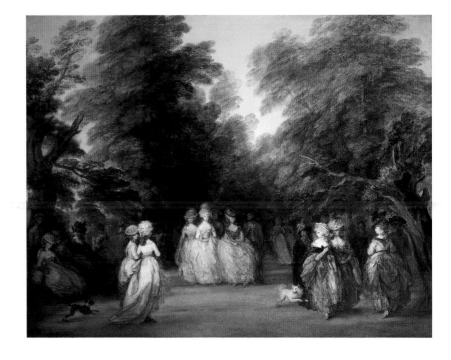

Thomas Gainsborough (1727–88)
Gainsborough was born in Suffolk,
studied painting in London after 1740,
moved to Ipswich in 1752, and then
to Bath in 1759. This portrait and
landscape painter was strongly
influenced by the works of Flemish
artists, particularly Rubens and
Van Dyck. Gainsborough returned
to London in 1774.

Gainsborough could almost have observed this scene from his London residence, looking out into nearby St. James's Park, or he could have conjured it up with the model landscapes and dolls he used to toy with in his studio, or perhaps he saw it in a dream. Today, the Mall has become the broad avenue the Queen descends in her carriage, coming from Buckingham Palace.

This picture, already described by critics in the year it was painted—1783—as "very fine" and "magnificent," was recognized as something new for Gainsborough—neither one of his usual portraits with a landscape background nor a pure landscape, but instead a complex design of rhythmically arranged figures shown gliding effortlessly along the broad paths of a heavenly park. The sky is clear and unclouded, the distant trees seem to sway in a gentle wind, and all the characters are young, elegant, and carefree. The three vertical waves that sweep across the composition made it seem, in one contemporary's words, "all aflutter, like a lady's fan."

The artist most frequently cited as a possible inspiration for this unusual painting was Watteau, the French artist who, sixty, seventy years before, had specialized in painting similar scenes of elegant folk promenading in idealized gardens. But Watteau painted on a nearly miniature scale; one of his pictures would fit in a corner of this one. Yet it was not merely for that reason that a contemporary of Gainsborough said, "*The Mall* comes nearest to the manner of Watteau, but, it is Watteau far outdone."

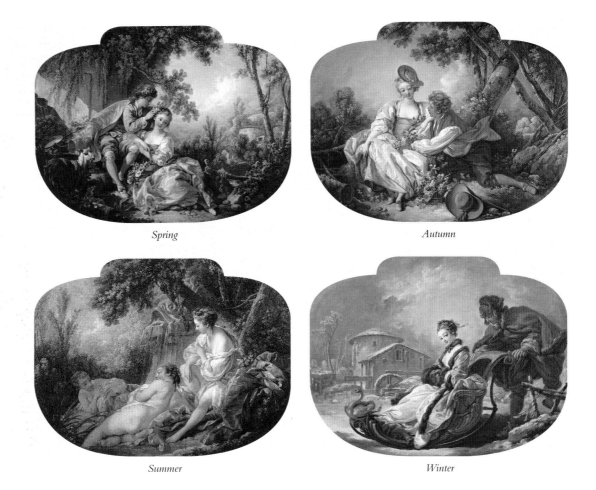

Spring

Autumn

Summer

Winter

Boucher

The Four Seasons
Oil, on canvas
22 ½ × 28 ¾ in. (57.2 × 73 cm)
Painted in 1755
Acc. No. 16.1.12–15

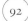

In these four paintings, François Boucher treats the age-old subject of the Four Seasons with a sensuous charm typical of the eighteenth-century French rococo style. Boucher made the paintings for one of the many residences of his major patron, Madame de Pompadour, the official mistress of Louis XV. Their irregular shape suggests that they were probably intended as overdoor decorations—curiously enough, it echoes the shape of the Chinese ginger jars in this hallway.

In place of the labors that traditionally illustrate the Seasons, Boucher depicts delightful amorous encounters in joyous colors, with not a single discordant note. Beginning at the left as you enter is *Spring*, where a youth adorns his lover's hair with flowers. Next, voluptuous bathing nudes represent *Summer*. (Incidentally, the only nudes that appear in paintings in The Frick Collection.) To the right of the door, in *Autumn*, a young man offers a lavish bunch of grapes to his fashionable beloved. Her mad little straw hat perches precariously on the front of her head.

But perhaps the most beguiling of all is *Winter*, which reflects the eighteenth-century European fascination with Russia. The frosty background here is very unusual for Boucher, vividly evoking the silence of a landscape buried under snow. A Tartar in pseudo-Russian dress pushes the heroine on an elaborate, rococo sleigh. Glancing out at us coyly, she sports a billowing fur-trimmed gown and a little fur necklace. Her hands may be warmed by a muff, but her upper body is completely exposed. It's a combination of luxury and seduction typical of Boucher, all treated in a fanciful, even humorous manner.

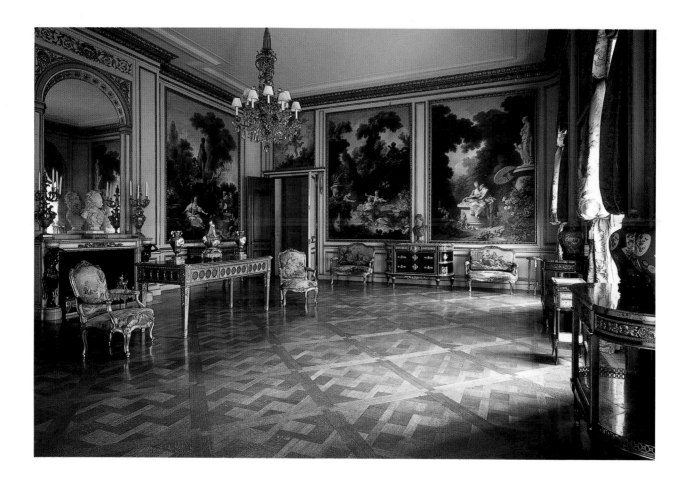

Fragonard Room

When the Fricks moved into their new residence in November 1914, the room in which you are now was the Drawing Room, so-named in reference to the habit of ladies "withdrawing" from the gentlemen after dinner. It had a painted wainscot and walls covered in figured red velvet, to create the effect of a room from the early eighteenth century in France. In December 1914, Mr. Frick had hanging here some large paintings by François Boucher that he was considering buying from Lord Duveen but never did, writing the dealer, "The more I looked at them the less I liked them."

Then, suddenly, everything about this room changed. Following the death of the great collector J. P. Morgan in 1913, portions of his fabulous collection were put on view at the Metropolitan Museum of Art, including the paintings by Fragonard that now surround you. Mr. Frick arranged to purchase these in February 1915 for $750,000, and ordered this room totally rebuilt to accommodate them. He further authorized the dealer Lord Duveen to acquire for over $5,000,000 the sculpture, chimneypiece, furniture, porcelains, and objects in gilt bronze that were chosen to complement Fragonard's collective masterpiece and that have remained in this room ever since.

The *boiseries*—or painted wall paneling—designed by Sir Charles Allom in the Louis XVI style, were executed in Paris in the middle of World War I, so that the newly named Fragonard Room could be opened in 1916.

Fragonard

The Progress of Love

Oil, on canvas

H. 125 in. (317.5 cm); W. either
84 ⅞ in. or 96 in. (215.5 or 243.8 cm)

Painted in 1771–3

Acc. No. 15.1.45–48

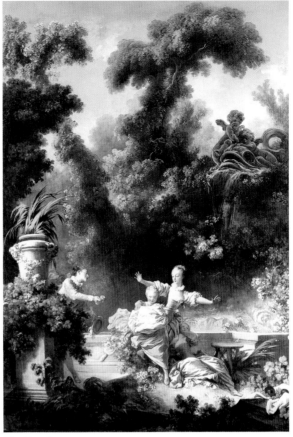

The Pursuit

Jean-Honoré Fragonard
(1732–1806)

Fragonard was born in Grasse, but moved to Paris with his family while he was a child. He studied for a brief period with Chardin, and later with Boucher. He won the Prix de Rome in 1752 and four years later journeyed to Italy, where he studied until 1761. In 1765 he was received into the Academy and awarded the title peintre du roi. *After the Revolution, Fragonard lost his prominent position in Paris and died in poverty.*

The history of these paintings—one of the most powerful evocations of love in the history of art—is linked with the career of the Comtesse du Barry, the last mistress of Louis XV. For a pleasure pavilion she commissioned from the architect Ledoux in 1771, the Countess ordered from Fragonard four canvases depicting "the four ages of love." They are the large canvases flanking the fireplace and to the right, on the adjacent south wall. Together they illustrate a love story such as any of us might have known. Beginning on the south wall, they advance from a flirtatious proposal (a young man springs out to offer a girl a rose), to a furtive meeting at the left (the lover scales the wall of a garden), to consummation or marriage on the other side of the fireplace (the girl crowns her lover with roses), to the calm enjoyment of a happy union (the reading of the love letters).

Yet, for all their beauty and passion, Madame du Barry soon returned the canvases to the artist and ordered replacements from another. Were the resemblances between the red-coated lover and Louis XV potentially embarrassing? Did the exuberant canvases seem a little old-fashioned amidst the cool neoclassicism of Ledoux's avant-garde pavilion?

For whatever reason, Fragonard was left holding onto his creations for another twenty years. Then, adding ten more canvases, he installed the lot in a cousin's villa in southern France. In adding the desolate figure, alone by the column, he may have been evoking the solitude of Madame du Barry, whose royal lover was dead by then.

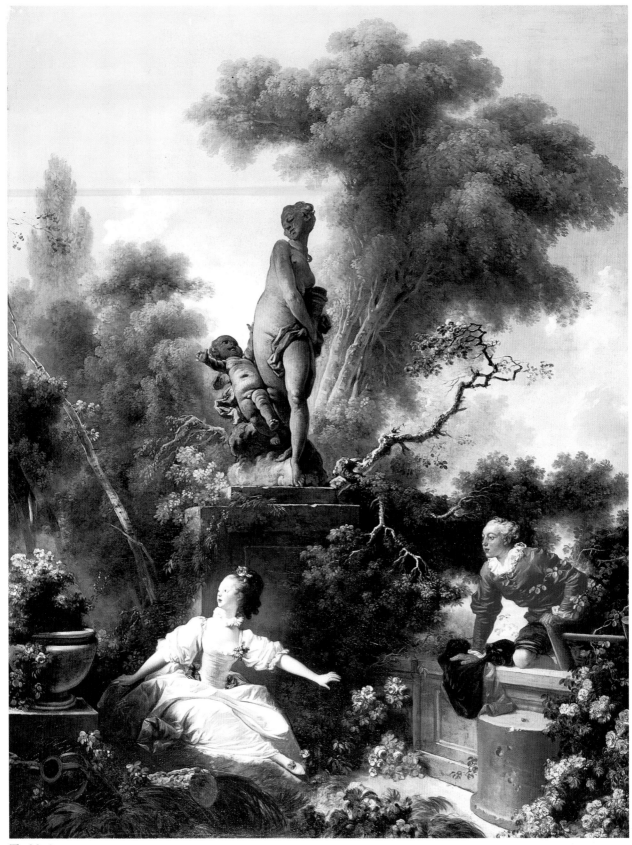

The Meeting

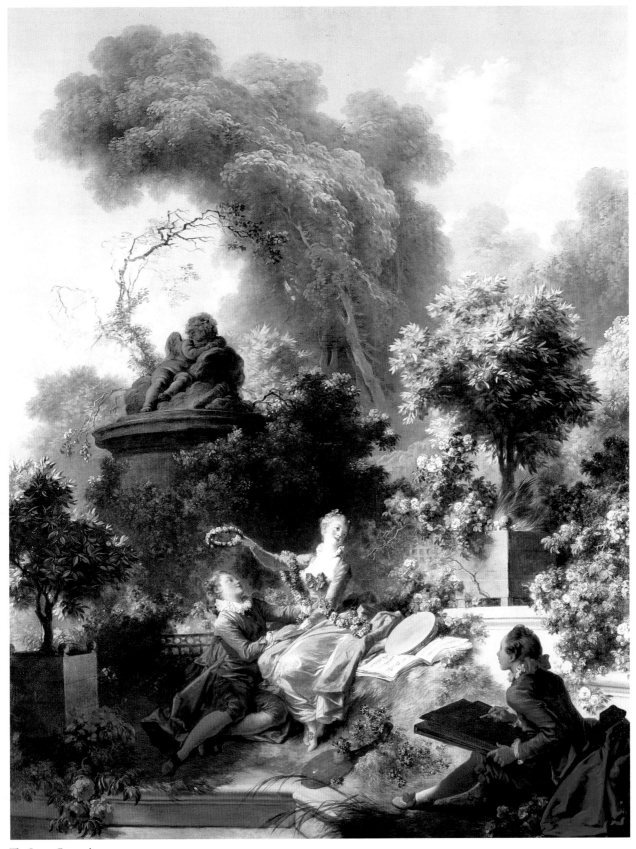

The Lover Crowned

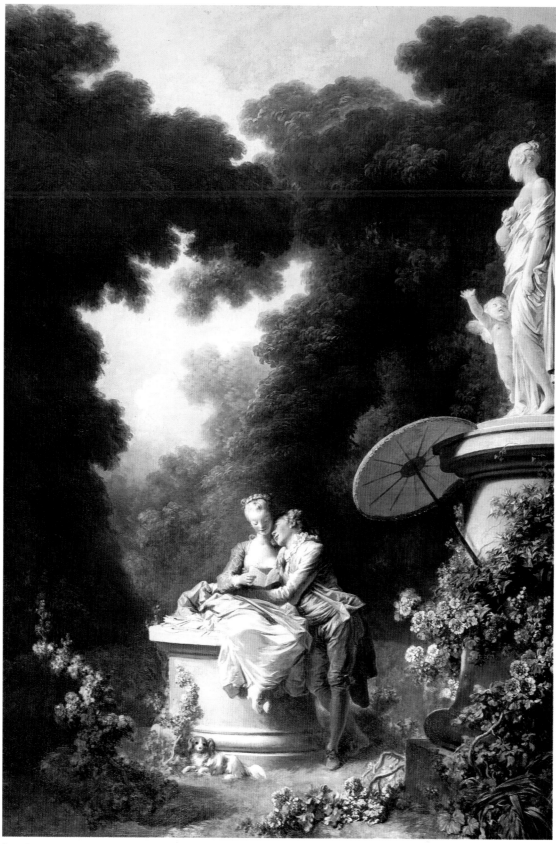

Love Letters

Clodion

Zephyrus and Flora
Terracotta
H. 20 ¾ in. (52.7 cm)
Signed and dated: CLODION. / 1799
Acc. No. 15.2.76

Houdon

Comtesse du Cayla
Marble
H. of bust 21 ¼ in. (54 cm);
H. of stand 5 ⅝ in. (14.3 cm)
Signed and dated:
A. HOUDON, F. AN.1777
Acc. No. 16.2.77

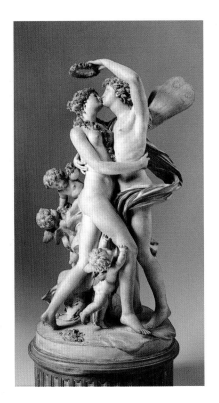 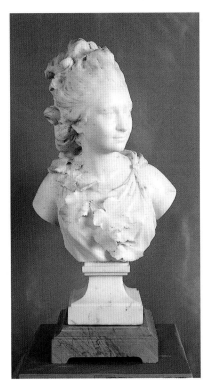

Clodion (Claude Michel)
(1738–1814)
*Clodion was born in Nancy and went
to Paris to study first with his uncle,
Lambert-Sigisbert Adam, and then
with Pigalle. Between 1762 and 1767
he was a student at the French Academy
in Rome, returning to Paris in 1771.
He supervised an active workshop
that produced marble sculpture, stone
architectural reliefs, and small terracotta
statuettes.*

Jean-Antoine Houdon (1741–1828)
*Houdon began his studies with René-
Michel Slodtz and entered the French
Academy in Rome in 1764. After his
return to Paris in 1768, he was widely
praised as a sculptor of portrait busts,
of which he often made reproductions in
marble, terracotta, plaster, or bronze.*

The late eighteenth- and early nineteenth-century French sculptor known as Clodion specialized in themes of antiquity, like this joyous terracotta, based on the imagery of the ancient poet Ovid. Encouraged by a trio of cupids, the goddess of flowers, Flora, is locked in a tender embrace with Zephyrus, the west wind. The winged god holds a wreath of roses over his bride's head—an amorous gesture that makes a perfect sculptural counterpart to the exuberant painting by Fragonard on the wall to the right.

Clodion excelled in such small terracottas. Fired clay is a medium of great fragility, presenting major technical challenges. But it offers endless possibilities for varied surfaces—from the little roses lying at the lovers' feet, to the dense garland across Flora's breast, the billowing drapery, abundant locks, or smooth elegant limbs of the unclothed figures.

Now look behind you, at the mantelpiece. There, Houdon's marble bust of the Comtesse du Cayla holds sway over the room, one of the greatest exercises in carving imaginable. Houdon portrays the Countess as a carefree bacchante with vine leaves cascading across her simple garment and roses in her upswept hair. Her tresses are coming undone—as you can see in the mirror. I hope you'll walk around so you can see her from the front too.

When this bust was first exhibited in 1777, contemporaries described the subject as intoxicated, and there certainly is a hint of abandon in Houdon's transformation of an elegant contemporary woman into a mythical creature. But it's all based on the sculptor's powerful sense of human anatomy—beneath that exquisite skin, he never lets us forget that there's a skull.

Joubert and Lacroix

Commode with Pictorial Marquetry
Oak and mahogany, veneered with
marquetry and panels of various woods,
mounted with gilt bronze, top of
Sarrancolin marble
H. 35 ¾ in. (90.8 cm); W. 73 ½ in.
(186.7 cm); D. 26 ½ in. (66.1 cm)
Made in 1769
Acc. No. 15.5.37

(III)

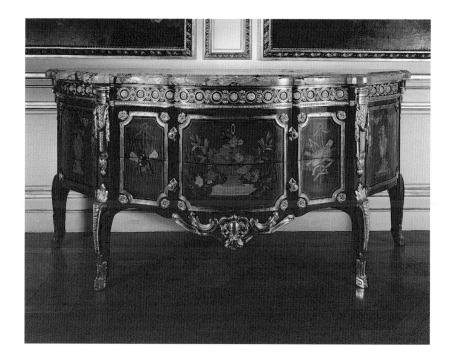

Gilles Joubert (1689–1775)
*Joubert became the main supplier of
furniture to the Crown around 1751
and succeeded Jean-François Oeben as
ébéniste du roi in 1763. Due to the
high number of royal commissions he
received, he may have consigned some
work to artists outside his shop. Only
a small number of his pieces survive.*

Roger Lacroix (1728–99)
*Lacroix, also known by his father's
Flemish name of Vandercruse, enjoyed
great success as a cabinetmaker for the
Parisian nobility. The Duc d'Orleans,
Madame du Barry, and the King
admired his furniture pieces, which were
decorated with a variety of marquetry
designs, mahogany veneering, and
Sèvres porcelain plaques.*

We have extraordinarily detailed records on the history of this commode, or
chest of drawers. On July 5, 1769, Gilles Joubert, cabinetmaker to the King,
delivered it to Louis XV's daughter Madame Victoire to use in her newly
decorated bedchamber at the Château de Compiègne. She and her three
sisters were rearranging their rooms to be closer to their father following the
death of their brother, the Dauphin.

The commode, with the chair, was the most common furniture type
of the eighteenth century. This excellent piece represents that transitional
moment in style between the curving, flowing forms of the rococo and
the more stable, ordered elements of neoclassicism. So while the sides and
front swell out majestically, the frieze that runs along the top is relatively
restrained. The brilliant, double-gilded mounts complement the naturalistic
marquetry, made of many different types of wood and originally augmented
with staining, now faded. The natural abstract beauty of the original marble
top is the crowning glory—few actually survive the centuries.

The Frick commode was one of three commissioned by the royal
family from Joubert, who was renowned for his marquetry. Intended more
for decoration than for practical use, it later embellished a room in Louis
XVI's apartments where the King had his wig repowdered and his boots
removed after hunting.

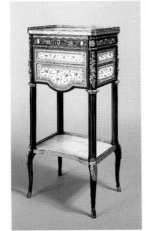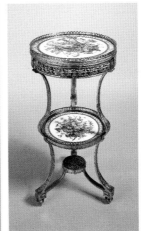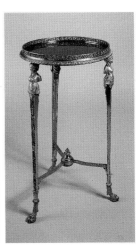

Carlin

*Mechanical Reading and Writing Table
with Sèvres Porcelain Plaques*
Oak, veneered with sycamore maple,
inset with soft-paste Sèvres porcelain
plaques, mounted with gilt bronze
H. closed 30 ⅜ in. (77.2 cm); H. fully
extended 45 ¾ in. (116.1 cm); W. 14 ⅛
in. (35.9 cm); D. 10 ¾ in. (27.3 cm)
Made probably in 1781
Acc. No. 15.5.62

Carlin

*Tripod Table with Sèvres
Porcelain Plaques*
Gilt bronze and oak, surfaced
with soft-paste porcelain plaques
H. 29 ½ in. (75 cm); D. 14 ⅝ in. (36.4 cm)
Made about 1783
Acc. No. 18.5.61

French, about 1785
*Gilt-Bronze Tripod Table
with Lapis Lazuli Top*
Frame of gilt bronze, iron, and oak,
top of lapis lazuli over slate
H. 28 ¼ in. (71.8 cm); D. 16 ¼ in.
(41.3 cm)
Made about 1785
Acc. No. 15.5.60

Martin Carlin (*c.*1730–85)
*This German furniture-maker trained
in Paris with Jean-François Oeben
and was admitted to the guild of
menuisiers-ébénistes in 1766. He
made a specialty of small-scale furniture
with Japanese lacquer panels, plaques
of Sèvres porcelain, and pietra dura.
Dealers such as Daguerre and Darnault
supplied Carlin's pieces to members
of the European nobility, such as the
daughters of Louis XV and Madame
du Barry.*

The diminutive scale of the elegant tables in both corners of this wall and at the center reflects the smaller size of French apartments favored during the reign of Louis XVI.

In the right-hand corner is a jewel-like tripod table, made perhaps by the renowned furniture-maker Martin Carlin. It was designed to show off two magnificent Sèvres porcelain plaques with sumptuous flowers, some still fresh with dew, painted by an artist named Bouilliat. Since porcelain does not fade, we experience that extraordinary effect of "you are there," right back in the eighteenth century! And the blossoms complement Fragonard's lush gardens on the walls of this room.

Carlin was definitely responsible for the little table in the center. Ostensibly intended for work, it's primarily an ingenious toy. By pushing appropriate buttons, the top tilts up to support a book, the sides slide out to hold candles, and the entire upper section rises and swivels to become a book stand. Such mechanical furniture became very popular in the late eighteenth century.

In the corner to your left is one of the most extraordinary pieces of neoclassical French furniture to have survived—an intricate tripod table made by a team of artisans. Here, three smiling caryatids support a disk of lapis lazuli assembled into an apparently seamless six-pointed star. The seductive, kaleidoscopic composition gives an illusion of great depth, seeming to materialize and dematerialize in an abstract design of breathtaking complexity. The lapis disk may have been made in Russia, then presented as a precious gift to some French connoisseur or nobleman who commissioned the table in order to show off the disk.

Sèvres Manufactory
Pot-Pourri in the Shape
of a Masted Ship
Soft-paste porcelain
H. excluding gilt-bronze plinth 17 ½ in.
(44.3 cm); W. 14 ⅞ in.
(37.8 cm); D. 7 ½ in. (19 cm)
Made about 1759
Acc. No. 16.9.7

117

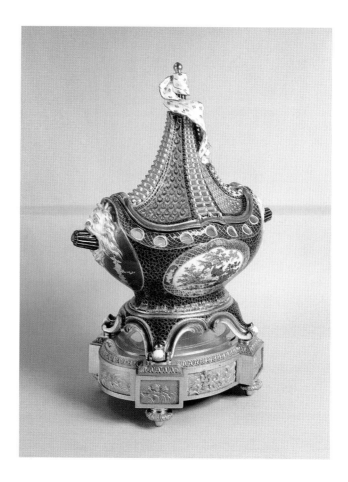

Sèvres Manufactory
Perhaps at the suggestion of Madame
de Pompadour, the royal porcelain facto-
ry was moved in 1752 from Vincennes
to the town of Sèvres, conveniently
located on the road from Paris to
Versailles. Louis XV became the sole
owner of the works in 1760, and there-
after organized an annual exhibition
and sale of porcelain at Versailles and
distributed pieces around the world as
diplomatic gifts. The factory produced
richly decorated soft- and hard-paste
porcelain until 1804, after which time
only hard-paste porcelain was made.
The manufactory remains open today.

More rare than paintings by Vermeer, the dozen surviving examples of pot-pourri vases in the shape of a masted ship are the treasures of great museums and of a few individual owners such as Queen Elizabeth II. It is their combination of extraordinary technical finesse, extravagant design, and masterly painting that make them so. If you have ever dabbled with throwing a pot, you know what I'm talking about.

The French royal porcelain factory, located in a village called Sèvres, on the Seine west of Paris, produced during the second half of the eighteenth century (and on to the present day) splendid, useless objects like this. In their formal complexity and surface brilliance, these pieces constituted works of art as worthy of contemplation as a fine painting. Still, this object did serve a function as a container of dried petals and spices that would perfume a suitably luxurious room, from the openings in its lid and side.

In its fanciful conception, probably due to the designer Jean-Claude Duplessis, note how the hull of the ship seems to float above a line of puckered forms suggestive of waves, and how the pennant decorated with a fleur-de-lis seems to flap and twist around the masthead. But totally contradicting this three-dimensional illusionism, and the elaborate abstract surface patterns, are the startling depictions of exotic birds rendered with the precise detail of a naturalist.

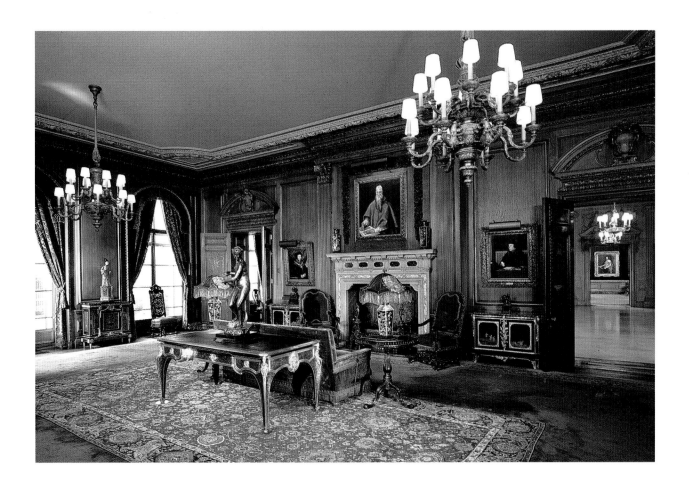

Living Hall

*Sir Charles Allom (1865–1947)
Allom founded the British interior
decorating firm of White, Allom and
Co. in 1893 and worked primarily for
members of the British royal family
during the first decades of the twentieth
century. Around 1905 he established
a firm in New York, serving the
American magnates Henry Clay Frick,
P.A.B. Widener, and William
Randolph Hearst. Allom was selected
as the Royal Commissioner for the
1912 international exhibition at
Brussels, Turin, and Rome, for which
he received a knighthood a year later.*

In this room the architect Thomas Hastings and the interior designer Sir
Charles Allom achieved one of their finest, most subtle creations—a suitable
setting for the remarkable works of art it contains. With the exception
of the removal of two bronzes to the East Gallery, the Living Hall appears
today as it did during Mr. Frick's lifetime.

With his usual historical precision, Sir Charles had specified that the
ceiling here should be of "cast ornamental plaster painted in detail such
as the Long Gallery at Aston House," an early seventeenth-century castle in
Warwickshire. But Mr. Frick objected, saying "Please see the ceilings are
almost plain," once again stressing his desire for restraint. Surely following
his client's wishes about what would be placed in this crucial gallery,
Sir Charles orchestrated against the carved oak paneling an elegant yet lively
harmony that included elements of wildly different origins. Against the
fireplace wall, for instance, were hung in a dramatic triangle three riveting
portraits from the sixteenth century—two by the German Holbein, one by
the Spanish El Greco. Beneath the former stand two massive ebony and
gilt-bronze French cabinets of the eighteenth century, topped with Italian
Renaissance bronzes. Into this European company are added the two
Chinese porcelains on the mantel, and the black-and-gold Japanese lacquer
panels that form the doors and sides of the cabinets. Centuries and continents
apart, these disparate elements fuse into a dramatic whole made possible
by their common level of quality.

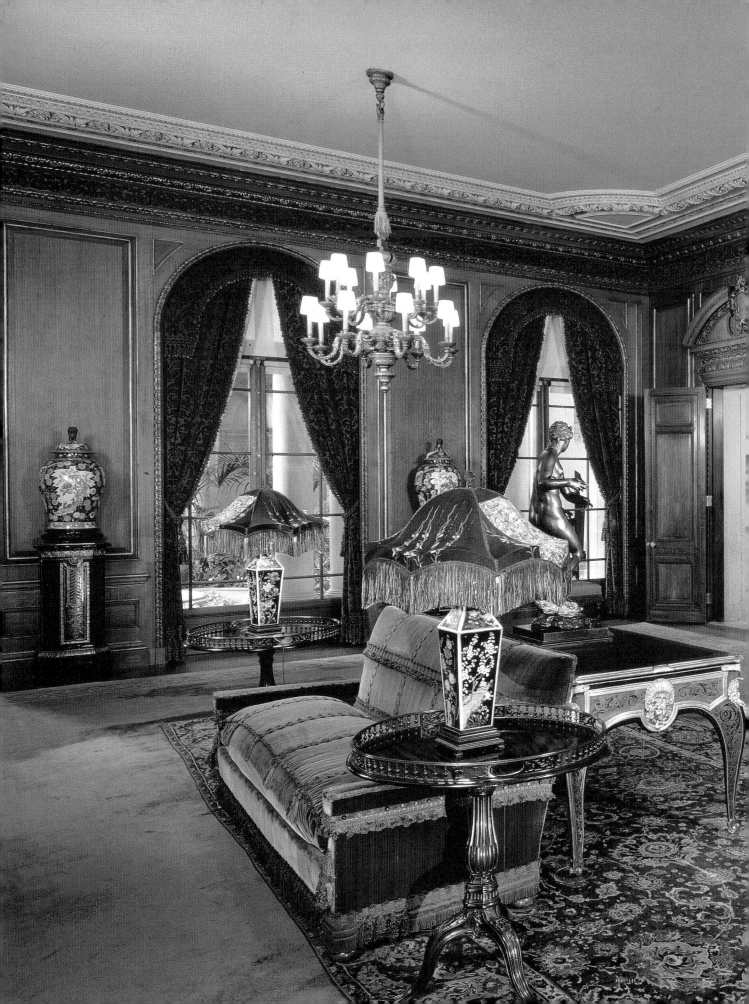

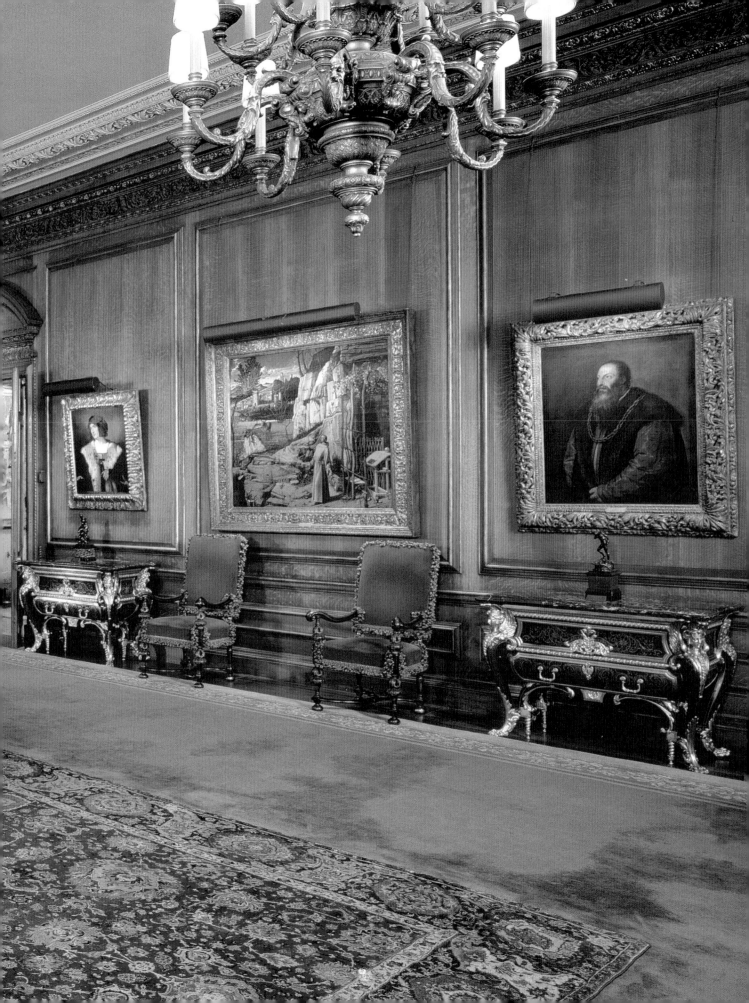

Holbein

Sir Thomas More

Oil, on panel

29 ½ x 23 ¾ in. (74.9 × 60.3 cm)

Dated: M.D.XXVII

Acc. No. 12.1.77

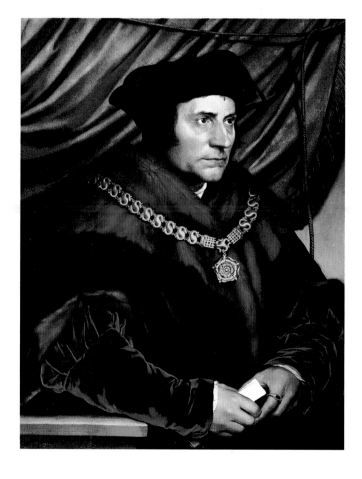

Hans Holbein the Younger
(1497/98–1543)

Holbein probably trained in Augsburg with his father, Hans Holbein the Elder. By 1516 he was practicing in Basel, where he met the humanist Erasmus, who would commission many works from the artist and provide him with letters of introduction for his travels abroad. Holbein made a visit to England between 1526 and 1528 and finally settled there in 1534, two years prior to his appointment as court painter to Henry VIII.

The image before you is so familiar that it's hard to believe that this is the real thing. But it is, and it's amazing.

The artist who painted it, Hans Holbein, came to London from Switzerland in 1526, only a year before he dated this portrait. Bearing a letter of introduction from the philosopher Erasmus, Holbein managed to enter the rarefied circle of Sir Thomas More and was soon living near him in Chelsea. More, in a letter back to Erasmus, spoke of Holbein as "a wonderful artist."

More, famed as a humanist scholar and author of *Utopia*, was a powerful statesman as well. By this time, he had already served Henry VIII as Privy Councillor for over a decade, and became his Lord Chancellor in 1529. But More subsequently refused to subscribe to the Act of Supremacy, making the King head of the Church of England, and for this, he was convicted of high treason and beheaded on July 6, 1535.

A drawing by Holbein at Windsor Castle was the model for this painting, but the artist made numerous changes from it. As an evocation of one man's mind and character, this portrait has few equals. As a demonstration of Holbein's bravura illusionism—look at the stubble of beard, or the irresistible feel of the velvet sleeves—it makes your knees go weak.

The gold S-S chain, by the way, was an emblem of service to the King. The letters stand for the motto "*Souvent me souvien,*" or "Think of me often."

Holbein

Thomas Cromwell

Oil, on panel

30 ⅞ × 25 ⅜ in. (78.4 × 64.4 cm)

Painted about 1532–3

Acc. No. 15.1.76

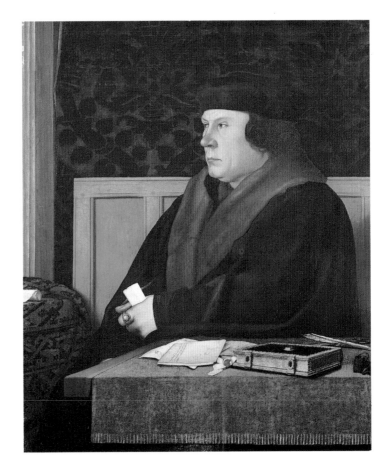

Mr. Frick took pleasure in reuniting pairs of portraits that had become separated. Thomas More, on the other side of the fireplace, and his mortal enemy Thomas Cromwell—who was largely responsible for his execution—were painted five years apart, and could at best be described as an ill-fated pair. They hang face to face, the interval between them charged with a tension that binds them more irrevocably than any married couple.

Unlike More, Cromwell rose from the working class, but went on to the highest administrative posts in the court of Henry VIII. *Unlike* More, Cromwell supported the Act of Supremacy; as chief architect of the English Reformation, he ruthlessly persecuted those who did not adhere to the new state religion. But *like* More, Cromwell, too, fell from favor; in 1540, five years after More's execution, he met with a similar fate.

Holbein painted this portrait on his return to England in 1532. Using a common device of a folded piece of paper—inserted here in an exquisite little still life—the artist informs us of Cromwell's current position as Master of the Jewel House. Can you make out the words?

The cooler tones and simpler background of the Cromwell portrait, as compared with the earlier one of More, are characteristic of the style of Holbein's second period in England. Once thought to be a copy of a lost original, this painting is now accepted as an autograph work. As for the artist's sympathy for his two subjects, you will have to decide for yourself.

El Greco
St. Jerome
Oil, on canvas
43 ½ × 37 ½ in. (110.5 × 95.3 cm)
Painted about 1590–1600
Acc. No. 05.1.67

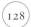

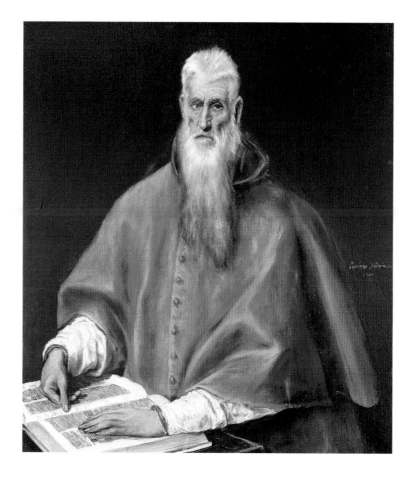

The solemn image of St. Jerome, placed high for dramatic impact, is the first thing you see when you enter the Living Hall. El Greco's compelling portrait of this learned man, with his long white beard, sets the very serious tone of this room, which is filled with objects of great value in every sense of the word.

Jerome was a fourth-century Roman scholar who dreamt that Christ reproved him for his love of pagan writing. To do penance, he fled to the desert, living as an ascetic and devoting himself to the Holy Scriptures. But he is best remembered for his translation of the Bible from Greek and Hebrew into Latin, then the most widespread common language. Jerome labored over this monumental task for the last thirty years of his life. Although since revised and supplemented, the so-called Vulgate is still the official version of the Bible according to the Catholic Church.

El Greco presents the venerated saint as an ascetic scholar and visionary—his cheeks hollow, his expression spiritual and intense, his body broad and impressive. Jerome wears a Cardinal's robes, although the office did not exist during his lifetime. The flickering reds of this imposing garment pick up the reds of the great Persian rug that lies in the middle of the room.

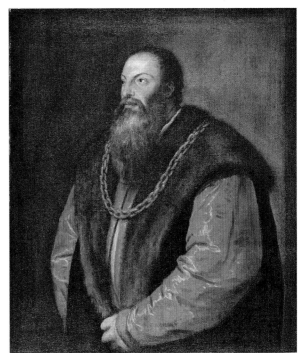

Titian
Portrait of a Man in a Red Cap
Oil, on canvas
32 ⅜ × 28 in. (82.3 × 71.1 cm)
Painted about 1516
Acc. No. 15.1.116

Titian
Pietro Aretino
Oil, on canvas
40 ⅛ × 33¾ in. (102 × 85.7 cm)
Painted probably between 1548 and 1551
Acc. No. 05.1.115

Titian (Tiziano Vecellio)
(*c.*1485/90–1576)
Succeeding Giovanni Bellini as the painter to the Republic of Venice, Titian won commissions from the Venetian elite, as well as from such celebrated patrons as the Este and Gonzaga families, Emperor Charles V, Charles' son Philip II, and Pope Paul II. Titian died in Venice in the Great Plague of 1576.

Mr. Frick left no statements of what he was after in his collecting—what types of art he enjoyed or didn't enjoy. The only evidence we have is the art itself. But these two portraits of totally different characters by Titian from the earlier and later years of his career really bring us close to who Mr. Frick was, and how he felt about people and art.

He seems to be savoring contrasts here—between the seductive, anonymous young man at the left and the powerful, celebrated older one on the right, the competition, perhaps, between one generation and another.

The youth is very beautiful, with his strong neck, refined face, soulful eyes, and sensitive mouth—someone people fall in love with. Even the gentle hand resting on his sword suggests a man of great sensitivity—maybe a poet or an artist. At the same time, Titian emphasizes the richness and elegance of his attire—the softness of that lavish fur, or the silver glint of the sword's hilt against the shine of golden satin.

You couldn't have a stronger contrast to this dreamy-eyed youth than the portrait of Pietro Aretino, to your right. Aretino was an extraordinary figure—author of lives of the saints, writer of innumerable letters and lascivious verse, literary blackmailer, knighted by Popes. His friends and patrons included many of the most prominent figures of his day—among them Titian, who did at least three portraits of him.

Of all the qualities that Titian captures here, what predominates is the sense of power, the brute strength of this massive, heavy, self-confident, and very rich man, swathed in sumptuous fabrics and fur. The subtle harmonies of gold and rust and brown here make up one of the great color schemes of all time, typical of the Venetian school.

Bellini

St. Francis in the Desert

Tempera and oil, on panel

49 × 55 in. (124.4 × 141.9 cm)

Signed: IOANNES BELLINUS

Painted about 1480

Acc. No. 15.1.3

Giovanni Bellini (*c.*1430–1516)
Giovanni and his brother Gentile
studied painting in the workshop of
their father, Jacopo. In 1483, Giovanni
succeeded Gentile as painter to the
Republic of Venice, executing numerous
devotional and mythological works for
the State, local parish churches, and
private patrons. Bellini was one of the
first Italian artists to master the use of
oil painting, a technique he learned
from Northern artists visiting or living
in Venice.

Many a non-believer has been struck dumb by the spiritual force of this painting, which may well be Giovanni Bellini's masterpiece—the finest work in The Frick Collection, and the greatest Renaissance painting in America. Also one of the best preserved.

Bellini has depicted St. Francis of Assisi transfixed as he receives the stigmata—the wounds of Christ's crucifixion—as it is believed he did in 1224 during a retreat on Mount La Verna. The wounds from the nails are faintly indicated on his outstretched palms.

While this subject was frequently represented in the late fifteenth century, it usually included a depiction of the Crucified Christ emitting rays. Here, however, the miracle is shown occurring through a transcendental light that originates at upper left, brightens the walls of the rock formations, and, in the right foreground, casts deep shadows behind the saint and the espaliered limbs that screen his workspace. Reinforcing this effect of an unnatural occurrence, the laurel tree at the upper left glows as if spotlit and bends as though blown by a powerful wind. But the shepherd with his flock, the donkey, and the crane all seem oblivious of what is going on.

The landscape is filled with marvelous details—animals, birds, persons, plants, castles, objects such as the skull and sandals, even a cord to ring the saint's "doorbell." But most touching of all is the scrap of paper blown against some branches at lower left. It bears the proud signature of the artist.

Boulle, after
Pair of Commodes with
Tendril Marquetry
Oak and walnut, veneered with
panels of tortoiseshell inlaid
with brass, mounted with gilt bronze
H. 34 ¾ in. (88.3 cm); W. 48 ¾ in.
(123.8 cm); D. 25 ¼ in. (64.2 cm)
Made about 1850
Acc. No. 16.5.2

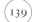

139

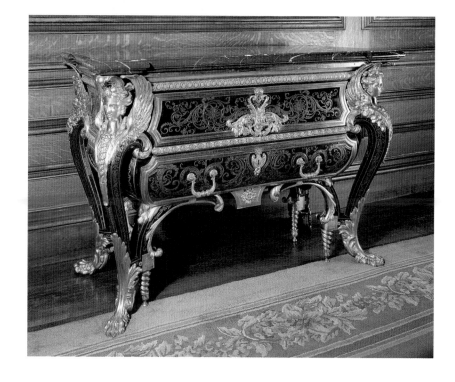

André-Charles Boulle (1642–1732)
Boulle received early fame in Paris as
cabinetmaker to Louis XIV and other
prominent members of the French
aristocracy. He perfected the art of
marquetry by veneering furniture with
floral designs in wood and other ornate
materials, such as gilt bronze, ebony,
and tortoiseshell. As the premier
ébéniste du roi, *Boulle was given a*
studio in the Louvre and designed
marquetry furniture and interiors for
the royal palace at Versailles.

Many great collectors owned furniture by André-Charles Boulle, and
Mr. Frick, who acquired some of the finest French furniture in America,
was no exception. All of the furniture in the Living Hall is either by or
in the manner of Boulle—cabinetmaker to King Louis XIV.

In the center of the room, the elegant writing table epitomizes Boulle's
sumptuously veneered panels of tortoiseshell, brass, and pewter, set off
against ebony and decorated with distinctive scrolling vines. The sylvan motif
harmonizes with the lavish gilt-bronze mounts—masks of woodland revelers
flank the middle drawer, and each end is adorned with smiling bacchantes.

Now look to the right, towards the windows facing the inner
courtyard. Between them, you'll see two urns on pedestals. The pedestals—
an unusual curved octagonal shape—also display Boulle's characteristic
contrasting black-and-gold ornament.

To the right, under the Titian portraits, are two spectacular "sarcoph-
agus" chests—precise replicas of commodes Boulle made for Louis XIV at
Versailles. And between the windows facing Fifth Avenue, you'll see a pair
of nineteenth-century English marble-topped cabinets, copies of Boulle
prototypes.

Finally, flanking the fireplace, are two beautiful chests by another great
eighteenth-century French cabinetmaker, Bernard Vanrisamburgh, who freely
adapted Boulle's style. Instead of fanciful marquetry, Vanrisamburgh adorned
his furniture with rare, imported panels of Japanese lacquer. The simplicity
of these asymmetrical Japanese landscapes makes a wonderful contrast with
the general classicism of Vanrisamburgh's design.

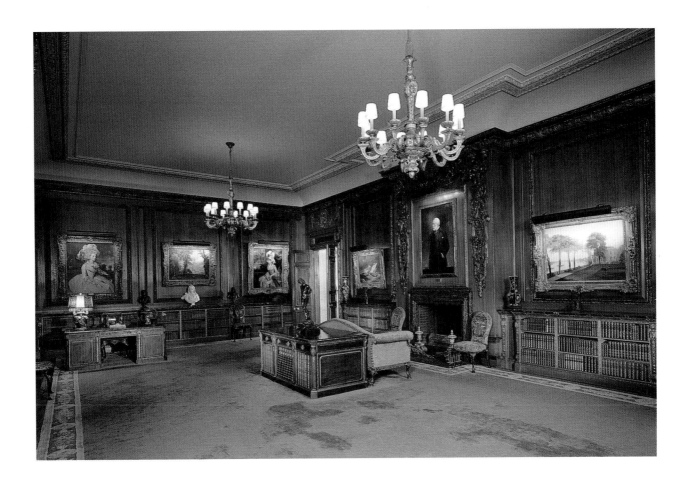

Library

Presiding over this room, just as he dominated every aspect of the residence and its collection, is Henry Clay Frick himself. The posthumous portrait above the fireplace is by Danish-born John C. Johansen. Framing it are the remarkable wood carvings of the craftsman Abraham Miller.

The work of designer Sir Charles Allom and architect Thomas Hastings, the Library evokes a grand eighteenth-century English interior. The bookshelves were kept waist-high to display great works of art on and above them—British paintings, Chinese porcelains, and small bronze sculptures. Mr. Frick was an avid reader, and the books themselves reflect his interests in history, art, and literature. His bookplate read, "Those who do not read are going back instead of progressing." Sir Charles even ordered the special tooled leather pads made to "lay over books as protection against dust."

Across from Mr. Frick's portrait is a library table designed by Sir Charles—like most of the furniture here. The central section includes the *Book of Wealth*—a history of riches beginning with the Pharaohs and including Mr. Frick himself. Its preface must have pleased the coke-and-steel magnate: "Wealth in its nobler aspect is not an unworthy theme," it reads. "If, as it is written, it is hard for a rich man to enter the kingdom of heaven, it may be a still more difficult task for the poor man."

Gainsborough
Lady Innes
Oil, on canvas
40 × 28 ⅝ in. (101.6 × 72.7 cm)
Painted about 1757
Acc. No. 14.1.58

144

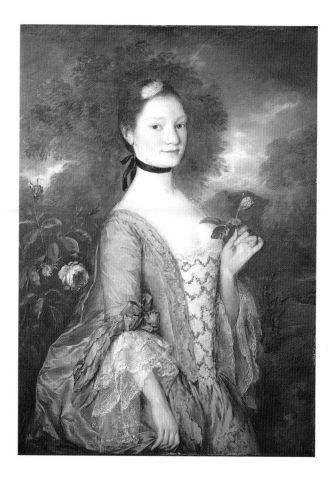

Mr. Frick purchased over the years no less than six paintings by Thomas Gainsborough, some of them more glamorous and on a grander scale than this one. But Sarah, Lady Innes, does not shy away in comparison. In fact, her lack of sophistication makes her all the more appealing. A little chubby, a little plain, she nevertheless faced Gainsborough with frank assurance, intelligence, and—one suspects—some humor. The artist, in turn, drew attention to her elegant hands and fine complexion, and wove around her symbols of the rose.

This flower, long emblematic of unspoiled youth, was associated with English beauties, especially débutantes, long before Elton John created "Goodbye, England's Rose" in memory of Princess Diana. "Rosebud" was also the name Mr. Frick bestowed upon his beloved daughter Martha, whose early death haunted him ever after. In the roses painted here so gloriously, Gainsborough even insinuated their passing, as they range from tight buds at mid-left and in Lady Innes' hand, to the full-blown beauty, drooping under its own weight, at center left.

Lady Innes herself would die about twelve years after Gainsborough painted her in the town of Ipswich, long before he achieved fame in London. Little is known about her, except that she married Sir William Innes, Captain of the Second Light Dragoons, in 1766.

The white feather in her hair and the black ribbon around her neck are audacious accents to the luxurious palette dominated by turquoise blue, white, and pink.

Romney
Lady Hamilton as "Nature"
Oil, on canvas
29 ⅞ × 24 ⅞ in. (75.8 × 62.8 cm)
Painted in 1782
Acc. No. 04.1.103

146

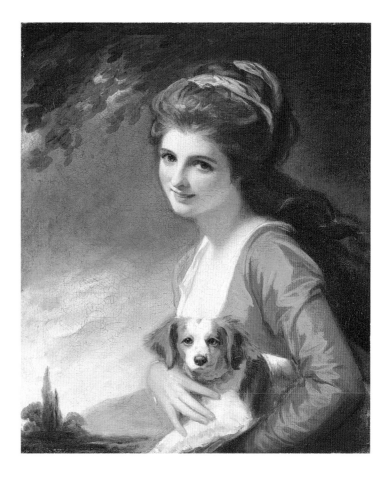

George Romney (1734–1802)
After beginning his career in northern England, Romney moved to London in 1762. He was a prolific portrait painter who vied with Sir Joshua Reynolds for patronage. Romney traveled to Paris in 1764 and spent two years in Italy after 1773.

A great favorite among The Frick Collection's many portraits of beautiful women, this one depicts an eighteenth-century superstar at the outset of her career. Daughter of a blacksmith, Emma Lyon was seventeen when she posed in 1782 for this portrait, commissioned by her lover Charles Greville. In his house a few years later, Emma met his uncle, Sir William Hamilton, British Ambassador to Naples. Soon thereafter, Greville arranged to unload his mistress on his uncle, much to her surprise. The older man delighted in her beauty and did his best to educate Emma in music, literature, and social refinements. He finally married her in 1791. As a noted connoisseur of fine art, Hamilton said of his wife: "She is better than anything in Nature. In her particular way she is finer than anything that is to be found in antique art." Subsequently, Lady Hamilton met Lord Horatio Nelson, with whom she had a notorious affair that continued until his death in 1805. Though she inherited from both her husband and her lover, extravagance led Emma into debt, and she died in poverty.

Part of her great success in Naples was due to her "attitudes"—a sort of romantic posturing achieved with the aids of shawls and classical draperies, in which she became a living work of art. This early portrait is fortunately devoid of such theatrics and simply shows us a ravishingly beautiful teenager casually pausing in her promenade as though one of us had caught her eye.

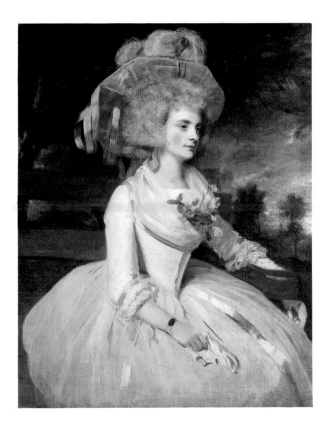 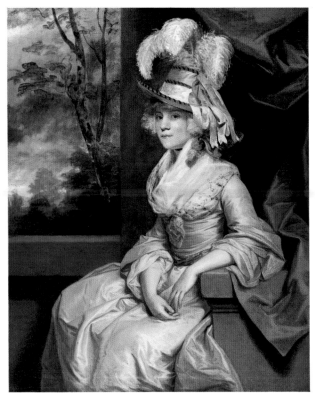

Reynolds

Lady Skipwith
Oil, on canvas
50 ½ × 40 ¼ in. (128.3 × 102.2 cm)
Painted in 1787
Acc. No. 06.1.102

Reynolds

Lady Taylor
Oil, on canvas
50 ⅛ × 40 ¼ in. (127.3 × 102.2 cm)
Painted about 1780
Acc. No. 10.1.101

Sir Joshua Reynolds often portrayed women—as he advised in the *Discourses on Art* he delivered as first President of the Royal Academy—in poses quoted from great art of the past. But *Lady Skipwith*, on the left here, and *Lady Taylor*, on the right, are simply magnificent portraits of very beautiful women, wearing very important hats.

Lady Skipwith was renowned for her horsemanship—her nephew remarked that "there was something rather formidable in her powdered hair and the riding habit, she generally wore." But here she has a rather sad, pensive quality, and the frothy outfit she—or the artist—has chosen allows Reynolds to indulge himself in a tour de force of variations on white, from her tulle gown with its satin trim, to her gloves, the pearl bracelet around her pale wrist, her powdered hair, or the plumes on her fantastic hat, itself a basically white confection. He sets this luminous vision against the quintessential Romantic backdrop—a dramatic, stormy sky.

In the portrait of Lady Taylor, at the right, the wonderful, freely-painted landscape seen through the window could stand by itself. But it makes a marvelous contrast to the "architecture" of this woman's hat, almost like a building balanced on her head. No wonder Hollywood designers looking for period detail have turned again and again to these images.

Lady Taylor seems the more robust. "Damn him!" cursed Reynolds' rival, Thomas Gainsborough. "How various he is!"

Constable

Salisbury Cathedral
from the Bishop's Garden
Oil, on canvas
35 × 44 ¼ in. (88.9 × 112.4 cm)
Signed and dated:
John Constable. f. London. 1826
Acc. No. 08.1.23

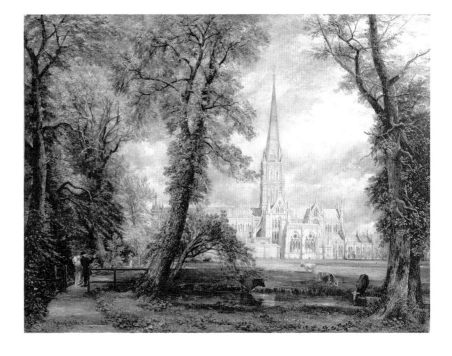

John Constable (1776–1837)
Constable left his native Suffolk in
1799 to study in London at the Royal
Academy, which did not elect him as a
full member until 1819. His finished
landscape paintings, which had a strong
impact on later French and English
nineteenth-century painters, were often
based on open-air sketches of local
scenery. Constable elevated the genre
of landscape painting to the height of
monumental history paintings.

This picture is a testimony to two of the favorite subjects of early nine-teenth-century artists and cultured folk in general—medieval monuments and nature. Through Constable's genius, the two here become, seemingly, one, as the large trees to the right soar upwards beyond the limits of the canvas and frame the spire of the great thirteenth-century cathedral as though the same divine force invigorated them all.

Salisbury and its cathedral were familiar to John Constable, through his intimate friendship with its Bishop, Dr. John Fisher, and his nephew, Archdeacon John Fisher, who had purchased some years earlier Constable's *The White Horse*, which you will soon see in the West Gallery of The Frick Collection.

Constable had painted an earlier version of the south façade of Salisbury, with a dark, cloudy sky. While his client the Bishop objected to this, requesting "a more serene sky," his nephew praised it, saying: "The Cathedral looks splendidly over the chimney piece. The picture requires a room full of light. Its internal splendour comes out in all its power, the spire sails away with the thunder-clouds." But Constable happily painted this second version of 1826 with its sunnier sky and more open composition, even including images of Dr. Fisher and his wife and daughter walking along the path to the left.

Today, one would probably not encounter cows grazing around the cathedral, but its park, or "close," has managed to resist the invasion of parking lots.

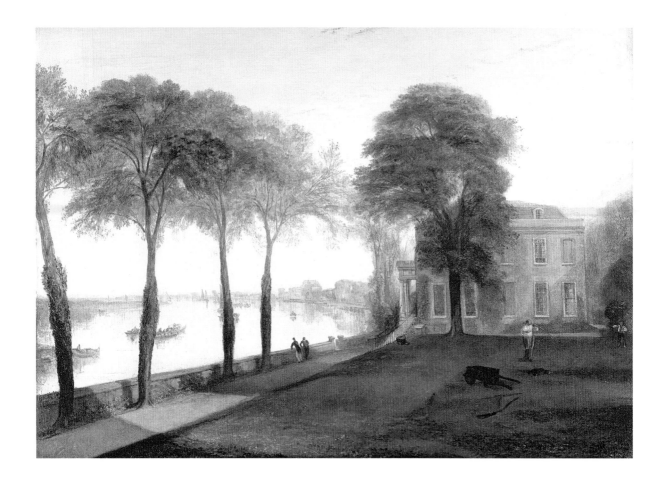

Turner

Mortlake Terrace:
Early Summer Morning
Oil, on canvas
36 ⅝ × 48 ½ in. (93 × 123.2 cm)
Painted in 1826
Acc. No. 09.1.121

Joseph Mallord William Turner
(1775–1851)
The son of a barber, Turner studied at
the Royal Academy, which elected him
a full member in 1802. He began his
career as a watercolorist, but changed
his medium to oil in the mid-1790s.
Many of his finished paintings were
based upon oil sketches he made during
his travels in England and on the
Continent.

We look down a tree-lined walkway to a large house on a river bank. The path divides the shaded, peaceful domain of William Moffatt at Mortlake on the Thames, seven miles west of London, from the glowing water. Nothing much is happening yet at Mortlake Terrace. The main player in this scene, the sun, is still off-stage, about to break in. Its advancing rays sweep down from the upper right, raking across the house and a portion of the lawn, filling the treetops and river with a cool radiance. The cut portion of the lawn indicates that the gardener has been at work for a while. He pauses to sharpen his scythe. A boy stands nearby, and further to the front, a broom and wheelbarrow lie ready to gather up and cart away the grass cuttings. At the parapet, two gentlemen—the viewer's surrogates—take in the river scene. Lightermen carrying freight push off from shore, while carefree young oarsmen propel their racing shells upriver.

Moffatt commissioned this "house portrait" from Turner, who lived in nearby Twickenham. The following summer the artist painted an evening view (now in the National Gallery of Art, Washington). This time he set up his easel in the house, looking down the promenade. The reversed viewpoint and saturated evening light of the second painting complement the first. Through the medium of light, of which Turner was a supreme master, we are presented with a small drama of life at Mortlake Terrace, and the timelessness of a summer day.

Coysevox

Louis XV as a Child of Six
Marble
H. 23 ½ in. (59 cm)
Dated: *1716*
Gift of Dr. and Mrs. Ira H. Kaufman
in 1990
Acc. No. 90.2.98

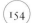

Antoine Coysevox (1640–1720)
*Coysevox moved from his native
Lyon to Paris in 1657, studying first
with Louis Lerambert and later at
the Academy, where he would serve
as director in 1702. He completed
commissions at Versailles, Rennes,
and Paris for the court of Louis XIV,
and executed tomb monuments and
portrait busts for private patrons.
He was the leading sculptor in France
at the end of the seventeenth and the
beginning of the eighteenth centuries.*

Though The Frick Collection includes two sculptures by Antoine Coysevox, works by this artist are otherwise rare in American museums. But the palace and gardens of Versailles are full of them, for Coysevox was the primary sculptor working for Louis XIV in the late seventeenth century. He was also the greatest portrait sculptor in France at the time.

The artist was seventy-six years old when he undertook the delicate task of memorializing a six-year-old child who had become King of France the previous year. The boy's father and grandfather, as well as his mother and elder brother, had all died before his great-grandfather Louis XIV did in 1715. Thus an intelligent but sensitive orphan came to be the ruler of one of the most powerful nations of the world.

Saint-Simon, author of the famous (and sharp-tongued) *Mémoires*, described this child-King as he appeared at an official ceremony two years after this bust was created: "serious, majestic, yet at the same time the prettiest thing imaginable, serious but with grace in his attitude, attentive, and not at all bored, fulfilling his august role very well, and without discomfort." Other contemporaries said the child was as beautiful as Cupid. The marble bust reinforces this vision of the young Louis, demonstrating how Coysevox was able successfully to capture both boyish charm and the grandeur of a monarch.

This unusual sculpture was given to The Frick Collection in 1990 by Dr. and Mrs. Ira H. Kaufman.

Stuart
George Washington
Oil, on canvas
29 ¼ × 24 in. (74.3 × 60.9 cm)
Painted in 1795–6
Acc. No. 18.1.112

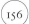

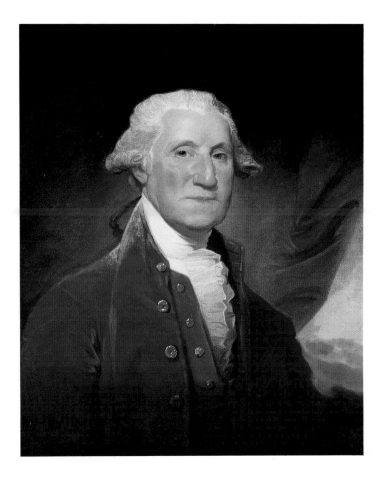

Gilbert Stuart (1755–1828)
Born in Rhode Island, Stuart trained briefly in Scotland and then spent nearly twenty years in London working as a student and assistant to Benjamin West. Stuart returned to America in the early 1790s and became one of his country's most eminent portraitists, working primarily in New York, Philadelphia, and Boston.

If the fledgling American republic had had a "court painter," the honors would have gone to Gilbert Stuart, whose straightforward style was particularly suited to many of the new country's leading citizens—including the first President himself. Stuart, who had trained in England, painted three portraits of George Washington from life and earned a fortune producing replicas of them.

He painted his first portrait of the President in Philadelphia in 1795. The picture was an immediate success, and the Philadelphia merchant John Vaughan quickly commissioned two copies.

Stuart's harmonies of wine-colored velvet against green satin are an elegant concept, but the focus here is Washington's strong, confident face, bathed in light. As American artist Benjamin West once said of Stuart, "He nails the face to the canvas."

Mr. Frick, who had a love of history and a deep pride in his country, seems to have bought this national icon more as an emblem than a work of art. The expatriate James McNeill Whistler is the only other major American artist to figure in The Frick Collection.

Lawrence
Lady Peel
Oil, on canvas
35 ¾ × 27 ⅞ in. (90.8 × 70.8 cm)
Painted in 1827
Acc. No. 04.1.83

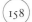

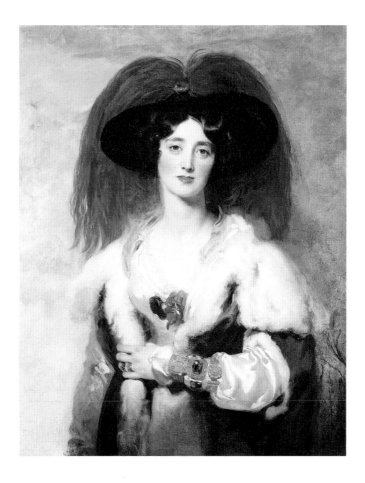

Sir Thomas Lawrence (1769–1830)
*A Bristol native, Lawrence moved to
London in 1787 and was appointed
Painter to the King at age twenty-two.
Three years later he was elected as
a full member of the Royal Academy,
which made him its president in 1820.
Lawrence enjoyed widespread renown
as a portraitist in England and on the
Continent, painting such dignitaries
as England's Queen Charlotte, Pope
Pius VII, and Charles X of France.*

There is an intriguing discrepancy between the refined features and gentle expression of this quintessential English beauty looking slightly down at us from an airy space, and the flamboyance of her costume. Is she a royal personage, or a figure from the stage? The vibrant red ostrich feathers, cascading to her shoulders from a black felt hat, are echoed in the rosy tints of her cheeks, lips, and the camellia tucked in her white satin dress. The single arm and hand crossing her body serve as prop on which to display a row of stupendous gold bracelets, encrusted with jewels, and a succession of rings. Portrayed in "fancy dress," rather than in the up-to-date fashions of the day, Julia, Lady Peel—wife of Sir Robert Peel, who was later Prime Minister under Queen Victoria—is both palpably present and yet removed from the here and now of Regency England.

Those who knew the couple would have seen a connection with another portrait of theirs of another beauty in a feathered hat, painted in full sunlight. Peel had recently acquired Rubens' famous *The Straw Hat* as the centerpiece of his collection of Dutch and Flemish masters. In commissioning Lawrence to paint his wife's portrait in homage to this masterpiece (now in The National Gallery, London), Peel expressed his pride in owning it while, at the same time, inviting comparison of his wife's beauty to that of the Flemish belle, and alluding to Sir Thomas Lawrence—the premier portraitist of the Regency—as the Rubens of his age.

Houdon

Marquis de Miromesnil

Marble

H. of bust 25 ½ in. (64.8 cm);
H. of stand 6 ¾ in. (17.2 cm)
Inscribed: A.T. HUE...DEMIROMENIL.
FAIT PAR HOUDON EN 1777
Acc. No. 35.2.78

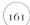

161

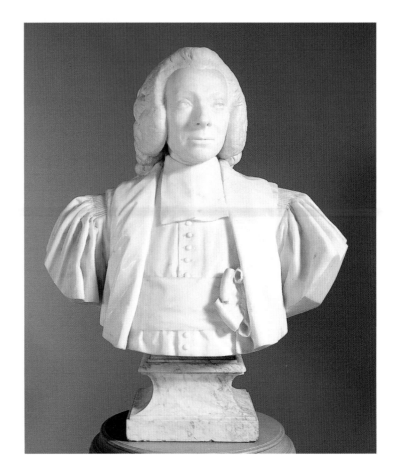

The rather intimidating marble man looking over you became the French Minister of Justice just three years before the sculptor Houdon inscribed the date 1777 along the back edge of this bust.

The Marquis de Miromesnil's powerful status is suggested at once by his professional garb—the outer robe with its voluminous sleeves, the buttoned cassock, the sash with its great bow—but even more by his magisterial wig, which Houdon left somewhat unfinished as one element in the play of textures the sculptor offers us in the absence of color.

Out of this heavy shell emerges the infinitely subtle face of a real man, whose expression seems to change as you move around him. Look at each profile separately, then the full face. Observe the details that tell us of his age—fifty-four: the loose jowls, the slight bags beneath the eyes, the beginning of a double chin and of lines across the brow. Is he only smiling, or about to speak? Does he seem friendly, crafty, or disdainful?

Creating the illusion in marble of moist and expressive eyes was Houdon's renowned speciality. See how he has drilled here into the marble tiny holes whose shadows create a transparent effect beneath Miromesnil's hooded eyelids.

Houdon's profound knowledge of anatomy makes us always aware that his subject's head consists, beneath the flesh, of a skull, an assemblage of bones, muscles, and cartilage, but also a brain. For Houdon had an innate sensitivity to the spirit of his subjects. This psychological "feel," combined with his scrupulous physical observations, bestowed an aura of immortality on his subjects. Don't *you* feel you have just passed a moment with someone rather special?

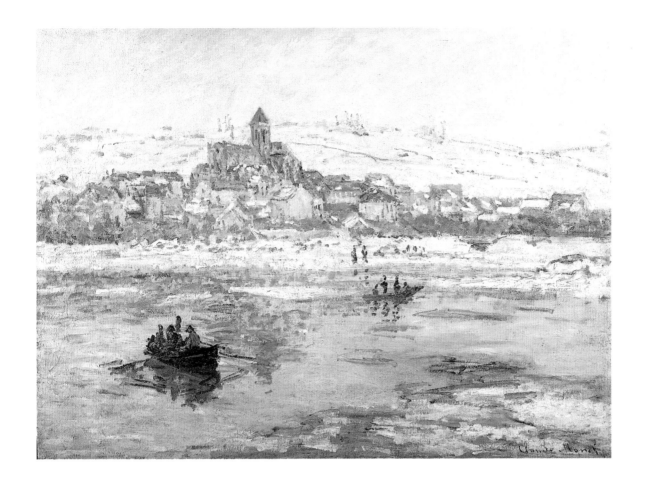

Monet

Vétheuil in Winter
Oil, on canvas
27 × 35 ⅜ in. (68 × 89.4 cm)
Signed: *Claude Monet*
Painted in 1878 or 1879
Acc. No. 42.1.146

Claude-Oscar Monet (1840–1926)
Monet was still a child when his parents moved from Paris, his birthplace, to Le Havre. In 1862 he returned to Paris, where he showed his work in the Salons of 1865, 1866, and 1868. Monet was a leading figure in the formation of the first Impressionist exhibition of 1874, which included paintings by friends such as Renoir, Pissarro, Cézanne, and Degas. After years of painting abroad and in France, Monet died at Giverny, the site of the gardens that inspired many of his later works.

Faced with mounting debts—a chronic problem during his early career—Claude Monet moved with his family in 1878 to the small town of Vétheuil on the Seine to seek cheaper lodgings. Generous loans from colleagues soon ran out. Buyers were scarce, and his wife was dying. "I don't have the strength to work anymore under these conditions," he declared. Yet he continued painting Vétheuil, from different vantage points at different times of the year.

He even constructed a floating studio—a flat-bottomed boat with just enough room for his easel—from which he may have painted this beautiful winter scene of the ice-clogged river and the town of Vétheuil, with its medieval church tower, on the far shore.

The palette of mauves, grays, and blue-greens is gorgeous, but it conveys a much more somber mood than we tend to associate with Impressionism. The painting seems truly chilling—reflecting perhaps not only the season and Monet's financial difficulties, but also the recent death of his wife Camille at the age of thirty-two.

Ingres
Comtesse d'Haussonville
Oil, on canvas
51 ⅞ × 36 ¼ in. (131.8 × 92 cm)
Signed and dated: *Ingres / 1845*
Acc. No. 27.1.81

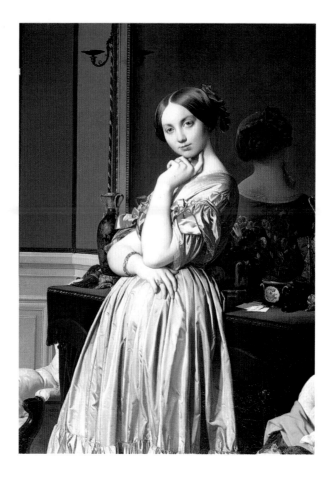

Jean-Auguste-Dominique Ingres
(1780–1867)
*Born in Montauban, Ingres went to
Paris to study with David in 1797.
He won the Prix de Rome in 1801,
but it was not until 1806 that he finally
traveled to Italy, where he was pro-
foundly influenced by classical sculpture
and the paintings of Raphael. After
ten active years back in Paris, Ingres
returned to Rome between 1835 and
1841 to serve as the Director of the
French Academy. At the end of that
term, he returned in triumph to France,
where he continued painting his famed
portraits and monumental subjects.*

This work resulted from a somewhat begrudging encounter—on the artist's part—between the greatest portrait painter in France, in his sixties, and a young Princess in her twenties—by then the mother of three. Louise, Princesse de Broglie, granddaughter of the formidable author Madame de Staël, had married the young Vicomte d'Haussonville at the age of eighteen. In her remarkably frank memoirs, Louise said of herself at this time, "I was destined to beguile, to attract, to seduce, and in the final reckoning to cause suffering in all those who sought their happiness in me." If this was the case with her husband, it did not affect his love for her. Following Louise's death, he instantly moved out of their Parisian residence and ordered a copy made of this portrait, which Louise had bequeathed to her daughter.

For her time and elevated social position, Louise was outspokenly independent and liberal. She published a number of books, including biographies of Byron and the Irish revolutionary Robert Emmet.

Ingres labored on this canvas for three years, with several false starts and a great many preparatory drawings. In the end, the artist noted that the finished work had "aroused a storm of approval." One close friend of the family told him, "You must have been in love to depict her this way." And indeed there is something provocatively intimate in this scene, as though Ingres had cornered his prey in the corner of her boudoir, nonchalantly leaning on an upholstered fireplace.

Belanger
Blue Marble Table
Marble, mounted with gilt bronze
H. 37 ½ in. (95.2 cm); W. 81 ⅛ in.
(206 cm); D. 27 in. (68.6 cm)
Made in 1781
Acc. No. 15.5.59

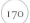

François-Joseph Belanger
(1744–1818)
*This architect and landscape designer
began his career in 1767 as a designer of
ephemera for the* Menus Plaisirs du
Roi. *Ten years later he purchased the
office of* premier architecte *to the
King's brother, the Comte d'Artois,
for whom he constructed and decorated
the Château de Bagatelle in the Bois de
Boulogne. The architect also designed
residences for several members of the
Parisian aristocracy and introduced
the Picturesque garden style to France.*

This table with its neoclassical mounts was one of the costliest and most magnificent pieces of furniture produced in France in the late eighteenth century. Its acquisition by Mr. Frick in 1915 from the estate of J. P. Morgan indicated to what extent Mr. Frick was willing to go to raise the quality of the decorative arts in his collection to equal that of his famous paintings.

The table was commissioned by the Duchesse de Mazarin to ornament the *grand salon* of her Parisian mansion on the Quai Malaquais. It would have stood under a large mirror, opposite a blue marble chimneypiece designed by the same architect who designed the table—François-Joseph Belanger. Another artist—the sculptor Bocciardi or Adam—carved the marble components of the table, and Pierre Gouthière, the greatest craftsman of bronze ornaments during the reign of Louis XVI, created the amazing decorative elements. When the Duchess died suddenly in 1781, at age forty-five, the project came to a halt before the table was finished.

To appreciate this wonder, first regard the architect's contribution in the dialogue between rectilinear and curved elements in the general design, the play between circles and squares. Then, as you examine the decorative elements—the central bacchante mask, the long staff of Bacchus wrapped with leaves and tipped with pine cones, the Ionic capitals—note the contrasts between matte finish and burnished highlights. This subtlety was Gouthière's signature.

Corot

*The Arch of Constantine
and the Forum, Rome*
Oil, on paper, mounted on canvas
10 ⅝ × 16 ½ in. (27 × 41.9 cm)
Painted in 1843
Gift of Mr. and Mrs. Eugene Victor
Thaw in 1994
Acc. No. 94.1.175

Corot

Ville-d'Avray
Oil, on canvas
17 ¼ × 29 ¼ in. (43.8 × 74.3 cm)
Signed: COROT
Painted about 1860
Acc. No. 98.1.27

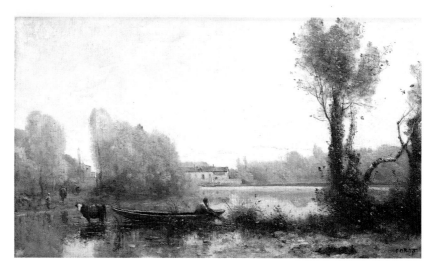

Jean-Baptiste-Camille Corot
(1796–1875)
*Corot was born and trained in Paris,
where he later gained critical acclaim for
the paintings he exhibited at the Salon.
He spent his early years working at
Rouen, in the forest of Fontainebleau,
and at Ville-d'Avray. He made an
early trip to Italy between 1825 and
1828, returning there twice, in addition
to traveling to Switzerland, England,
and Holland.*

Corot made three trips to Italy during his early years, where he made small, roughly-finished oil studies that are very well known and prized by connoisseurs. This one, from his third and final trip in 1843, depicts the Arch of Constantine at the left, the Roman Forum, and other famous ruins long favored by artists, here reduced to their essential forms.

Corot often referred to these quiet sketches back in his studio when he prepared larger, more finished canvases for sale or exhibition. But today, their freshness and immediacy are valued for their own sake as tiny, almost abstract miracles of color, form, and light.

On the wall at the left, between the second and third windows, is a later Corot depicting Ville-d'Avray. Corot's own solid little house is in the center of the picture, framed by a feathery mass of trees.

Corot is still painting light here—on the right, we sense the pale pink beginnings of a sunset against the great arc of the sky. It's not the strong, contrasting, sudden light of Italy, but the diffused, moist atmosphere of the Île de France. And there's that dot of brilliant red that's in so many Corots, as if he were adjusting the tone by the presence of a small touch of pure color.

One of five Corots in the collection, this subtle, poetic landscape is Mr. Frick's earliest purchase still on display in the galleries—just a still pond with a cow standing in the water that many people might not even notice. But when Mr. Frick bought it, he wrote to his colleague Andrew Carnegie, "It is a Corot, not a large one in size, but immense in every other way—I think the gem of my collection." As of this moment, that's the only statement we have by Henry Clay Frick on any of his acquisitions.

Watteau

The Portal of Valenciennes

Oil, on canvas

12 ¾ × 16 in. (32.5 × 40.5 cm)

Painted in 1709–10

Purchased with funds from the bequest of
Arthemise Redpath in 1991

Acc. No. 91.1.173

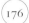

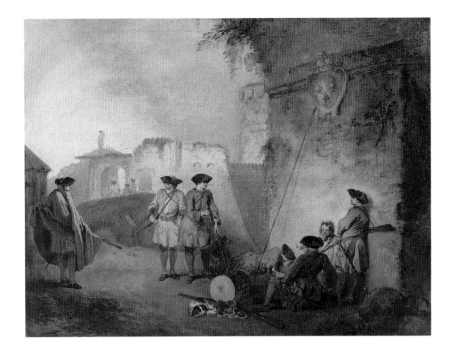

Jean-Antoine Watteau (1684–1721)
*Born in Valenciennes, Watteau moved
to Paris in 1702 and became a member
of the Academy there fifteen years
later. His painted subjects include* fêtes
galantes *and theatrical scenes, many
taken from the* commedia dell'arte.
*After a visit to London in 1719–20,
Watteau died of tuberculosis at the age
of thirty-seven.*

The early eighteenth-century French master Antoine Watteau, famed for
his dreamlike images of lovers dallying in fantastic gardens, began his career
on a more mundane level, as this early work demonstrates. Returning to his
birthplace, Valenciennes, in 1709, he found within its fortified walls hordes
of French soldiers awaiting their return to battle in the War of the Spanish
Succession, then being waged on the northern borders of France. Rather
than glorifying war as his predecessors had, Watteau subtly evoked here, in
an elegiac mode, the grimly uncertain future of the young men he has
portrayed so tenderly. Lolling about, sleeping, smoking, their drum and
musket at rest, their dog asleep, they seem blissfully indifferent to their future.
Yet, at one battle alone—at Malplaquet on September 11, 1709—over
30,000 lives were lost, more than half those claimed in the Vietnam War.
By managing to invoke a state of serenity in spite of the horrors of war all
about him, Watteau achieved something distinctly modern and unique
for his time. Fifty years later, the English aesthete Horace Walpole caught
this subtlety, when he wrote of the French artist's military subjects: "In
his halts and marches of armies, the careless slouch of his soldiers still retains
the air of a nation that aspires to be agreeable as well as victorious."

This gem by the French master long sought-after by The Frick
Collection was purchased in 1991 with funds bequeathed by Arthemise
Redpath.

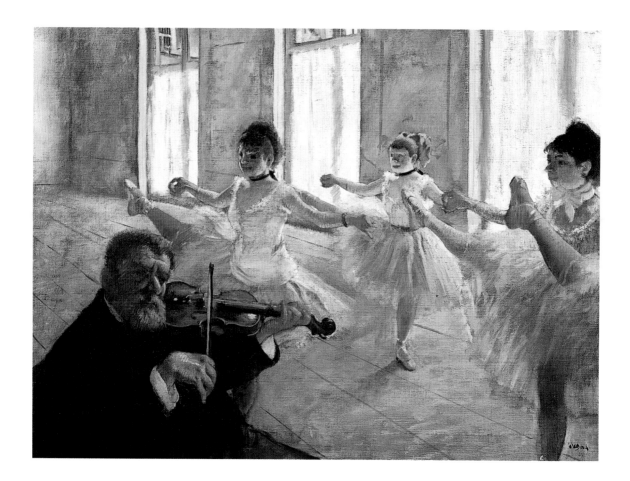

Degas

The Rehearsal
Oil, on canvas
18 ¾ × 24 in. (47.6 × 60.9 cm)
Signed (twice): *Degas*
Painted probably in 1878 or early 1879
Acc. No. 14.1.34

Hilaire-Germain-Edgar Degas
(1834–1917)
*Born in Paris, Degas was a student at
the École des Beaux-Arts and exhibited
paintings at the Salon between 1865
and 1870 before showing his work with
the Impressionists after 1874. Best
known for his paintings depicting urban
life, the ballet, and horse racing, Degas
was also a skilled sculptor, draftsman,
and photographer. The artist traveled
extensively throughout his life, visiting
Italy, England, Spain, America, and
Tangier.*

Of the many subjects treated by Edgar Degas, the dance is perhaps the most familiar. And this representation of a rehearsal at the old Paris Opera House is one of the most famous of the many works he made depicting that site. It's particularly effective for its almost mechanized rendition of the dancers, who look like puppets held up by strings. The old violinist is wonderfully pathetic—human and vulnerable, a real individual in contrast to the doll-like dancers moving to his music. Degas' up-tilted floor and startling cropping here, so often compared to photography, bring these young women so close to us that we can't fail to notice what a contemporary critic called their "special beauty compounded of plebeian coarseness and of grace."

Mr. Frick was not particularly enthusiastic about Impressionist paintings, but this picture must have been very important to him—it hung in his private sitting room on the second floor. It was also one of the few paintings he ever loaned. He sent it to an exhibition to benefit the cause of women's suffrage at the request of his friend and fellow collector Louisine Havemeyer, herself an ardent suffragette.

Bernini

Head of an Angel
Terracotta, coated with dark brown
paint flaked with copper
H. 9 ½ in. (24.1 cm); W. 8 ¾ in.
(22.2 cm); D. 6 ¼ in. (15.8 cm)
Made about 1655
Gift of Mr. and Mrs. Eugene Victor
Thaw in 1996
Acc. No. 96.2.104

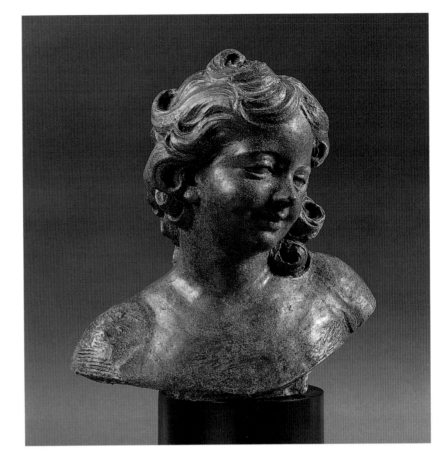

Gianlorenzo Bernini (1598–1680)
Bernini probably first worked as a
sculptor in his father's studio. He
achieved early fame for the sculptural
and architectural projects he executed
for Pope Urban VIII. Despite a
short fall from papal favor, Bernini
maintained his position as the leading
sculptor in Rome, completing grand
public and funerary monuments.

Andrea del Verrocchio (1434/37–88)
Born in Florence, Verrocchio began
his training as a goldsmith's apprentice.
After 1457 he joined the sculpture
workshop of either Desiderio da
Settignano or Antonio Rossellino.
By the mid-1460s, Verrocchio was the
leading sculptor in Florence and a
favorite of the Medici, executing
sculptural and painting commissions
for the city and local churches.

The bust at the right here portrays "Divine Beatrice of Aragon," daughter
of the King of Naples, who married her to the King of Hungary in 1476.
The early Italian sculptor Francesco Laurana must have made the bust
before Beatrice's marriage, because her delicate features look pudgy, almost
childlike, and the double chin and thickened nose so pronounced in later
portraits are only hinted at here.

Laurana specialized in such idealized busts of young ladies, with forms
reduced to their essence—such as the gentle arc of her shoulders played
against the smooth mass of marble that makes up the back of her head.
Once, she may have worn a filigreed metal cap. Yet Laurana creates a mood
here too—the young Beatrice seems drowsy, but also slightly petulant.

In the center of the wall is a recent gift by Mr. and Mrs. Eugene
Victor Thaw—a rare terracotta *Head of an Angel* by the seventeenth-century
baroque master Bernini. This head is a study for a marble group depicting
Habakkuk and the Angel. The angel lifted the biblical prophet by the hair,
and carried him off to bring food to Daniel in the lions' den. Here, Bernini's
characteristic animation is evident in the blissful expression and windswept
hair of this heavenly being, while the malleable clay leaves evidence of his
supremely confident, rapid, and imaginative touch.

The unknown young woman in the third bust seems more lively than
Beatrice of Aragon. She appears alert and engaged, twisting her head slightly,
as if responding to someone nearby. Such subtle animation characterizes
the work of the fifteenth-century Florentine artist Andrea del Verrocchio,
who taught Leonardo da Vinci. The bust and Laurana's *Beatrice of Aragon*
were both gifts of John D. Rockefeller, Jr.

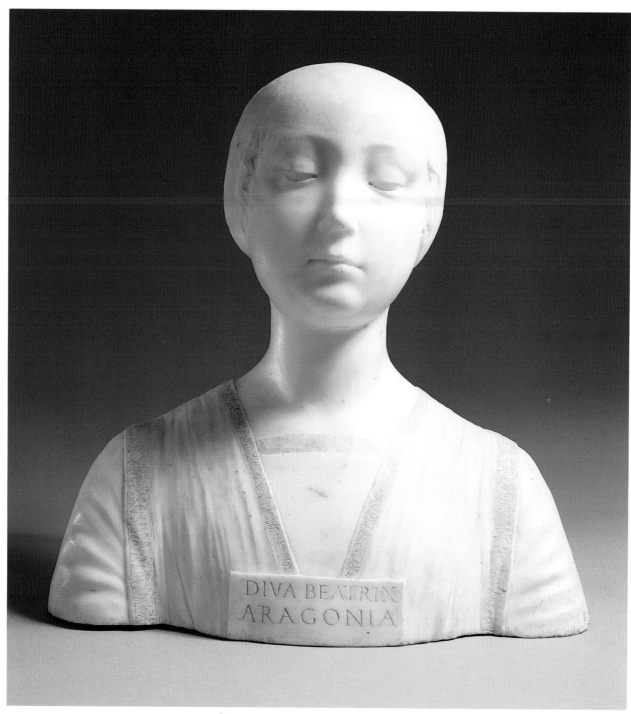

Laurana

Beatrice of Aragon
Marble
H. 16 in. (40.6 cm); W. 15 ⅞ in.
(40.4 cm); D. 7 ⅞ in. (20 cm)
Inscribed: DIVA BEATRIX / ARAGONIA
Made probably in the 1470s
Bequest of John D. Rockefeller, Jr.,
in 1961
Acc. No. 61.2.86

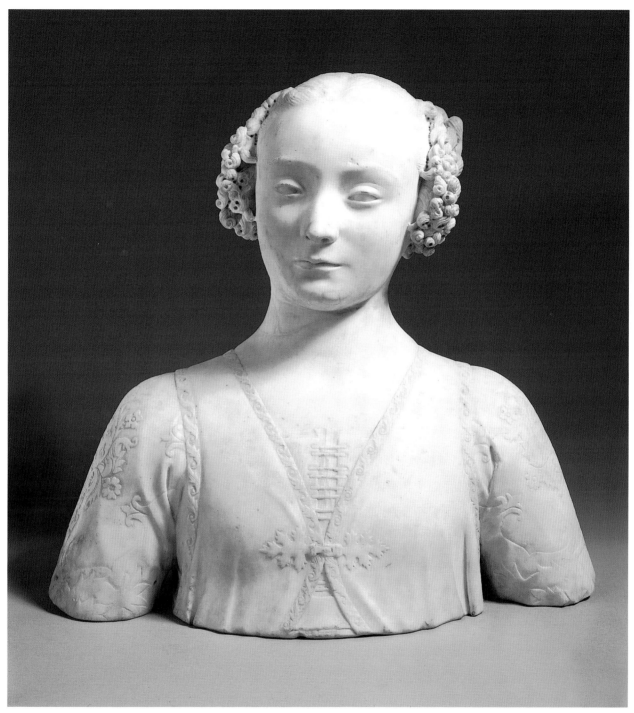

Verrocchio

Bust of a Young Woman
Marble
H. 18 ⅞ in. (48 cm); W. 19 ⁵⁄₁₆ in.
(48.7 cm); D. 9 ⅜ in. (23.8 cm)
Made probably between 1460 and 1483
Bequest of John D. Rockefeller, Jr.,
in 1961
Acc. No. 61.2.87

West Gallery

No, this room was not designed as a ballroom, but as an art gallery, just as you see it today. By the time this house was built, Mr. Frick's paintings were world-famous, and he wanted to show them off to best advantage. Most of them you see around you have always hung here, with the major exception of the Turners. Also, the double hanging of pictures customary in Mr. Frick's day—one Vermeer over another, for instance—has been eliminated.

The West Gallery allowed the architect Thomas Hastings to create one of the grandest interiors of his career. Measuring ninety-six feet in length, thirty-three across, and twenty-two high, the gallery has the grand scale of a Roman temple or bath. The heavy entablature, the coffered ceiling, and extensive use of marble heighten the effect. All this was no coincidence, for Hastings was consciously evoking historical precedents here, both from the Italian Renaissance and from antiquity. This pleased Mr. Frick, who wrote before the room was completed, "The picture gallery is going to be a dream. I like its proportions immensely."

The gallery was furnished as sparsely then as now, though there were sofas and comfortable chairs grouped around a fireplace at one end of the room. That element was removed in the early 1930s, when the architect John Russell Pope added the adjacent Oval and East Galleries that continue Hastings' scheme in a grand and harmonious progression to the east.

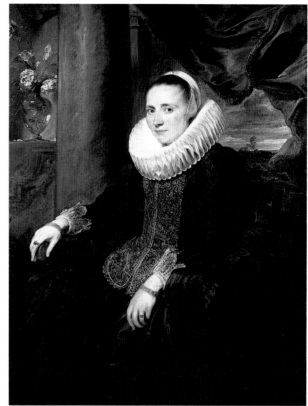

Van Dyck
Frans Snyders
Oil, on canvas
56 ⅛ × 41 ½ in. (142.5 × 105.4 cm)
Painted about 1620
Acc. No. 09.1.39

Van Dyck
Margareta Snyders
Oil, on canvas
51 ½ × 39 ⅛ in. (130.7 × 99.3 cm)
Painted about 1620
Acc. No. 09.1.42

Sir Anthony Van Dyck (1599–1641)
*Born in Antwerp, Van Dyck was
apprenticed at the age of ten to Hendrik
van Balen and worked as Rubens' chief
assistant after 1615. He was named
court painter to James I of England in
1620, but a year later returned to
Antwerp and then traveled to Italy,
where he worked until 1627. Van Dyck
took up residence again in England in
1632, resuming work as a portrait
painter at the Stuart court.*

It may seem unlikely, but this patrician with a poet's gaze was an artist who specialized in animal paintings, often violent scenes of hunting and combat. Frans Snyders also painted still lifes, and was a close friend of Van Dyck—the seventeenth-century Flemish prodigy whose legacy of aristocratic portraiture would be felt by artists for centuries to come.

Van Dyck executed this appealing portrait in his native Antwerp when he was only about twenty. Snyders' pale, sensitive features and delicate hands stand out against the daring palette of blacks, purples, and grays. The billowing drapery and severe architecture grant him a kind of aristocratic allure, and the extensive landscape suggests Snyders' own country estate.

Mr. Frick took a genuine delight in reuniting portraits of couples that had become separated over time, and the second picture to your right portrays Margareta Snyders. Her faint smile makes her seem a bit more accessible than her husband—the differences in their personalities are wonderfully evoked. She too sits in a palatial setting—not severe, but with rounded columns and a beautiful bouquet of flowers in a crystal vase tucked onto the shelf behind her. Both husband and wife wear black silk—but Margareta's gold-embroidered stomacher underscores the couple's wealth.

Turner

The Harbor of Dieppe
Oil, on canvas
68 ⅜ × 88 ¾ in. (173.7 × 225.4 cm)
Dated: *182*[6?]
Acc. No. 14.1.122

Turner

*Cologne: The Arrival of a
Packet-Boat: Evening*
Oil, and possibly watercolor, on canvas
66 ⅜ × 88 ¼ in. (168.6 × 224.1 cm)
Painted in 1826
Acc. No. 14.1.119

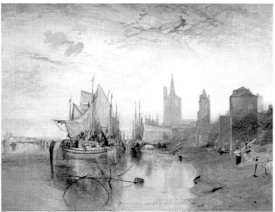

Midway in his career, Turner was working on three large canvases depicting Northern Continental ports—Dieppe and Cologne, here before you and on the opposite wall, and the Dutch harbor of Dordrecht, a picture now at the Yale Center for British Art.

The artist worked from sketches he had made on site in earlier years, detailing the structures you see along the right sides of both paintings, many of which still stand today.

Long before the advent of steamships and railroads, Dieppe, shown here, had been one of the key French ports for goods coming and going from England. Cologne, shown across the room, had a similarly long history of shipping up and down the Rhine.

However, Turner did not chose to focus on these two sites in order to document the history of shipping, but rather to try to capture the glorious light that each day transformed these picturesque sites—early morning in the case of Dieppe, evening with Cologne. Outrageously, he painted the sun itself twice in *Dieppe*, as a ball of white fire in the sky, and as slightly muted in the water below. In *Cologne*, the sun has withdrawn offstage, but sends resonating messages that cross the vast expanse of the sky and disappear into infinity.

As usual, Turner's critics were baffled by his daring, though one sensitively admitted that "amidst all this glitter and gaud of colors, it is impossible to shut our eyes to the wonderful skill, and to the lightness and brilliancy which he has effected."

Italian

Pair of Cassoni with Reliefs of Apollo

Carved walnut

H. 28 ⅛ in. (71.4 cm); L. 66 ¾ in.
(169.5 cm); D. 22 ⅜ in. (56.9 cm)

Made in the third quarter of the sixteenth
century

Acc. No. 16.5.80–16.5.81

190

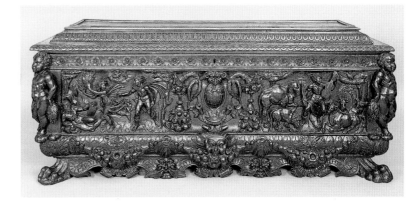

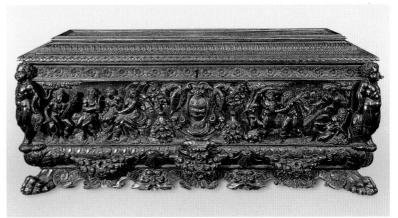

The Italian Renaissance furniture decorating the West Gallery is in perfect harmony with this great classical chamber. Roman architecture inspired the arched open ceiling and the friezes that run around it—echoed in the ornamentation of this lavish furniture. Mr. Frick purchased it—mainly from the sixteenth century—between 1915 and 1918, and today it's arranged largely as it was then. Three long tables occupy the center of the room, while along the walls stand four pairs of walnut chests called cassoni, and a series of X-shaped, folding "Savonarola" chairs, named after the Renaissance monk who was such a passionate Florentine reformer.

Cassoni served as "hope chests" for brides' trousseaux, storage for clothing and linens, and even as extra seating in a bedroom. Reflecting the Renaissance devotion to antiquity, their shape and ornamentation recall classical sarcophagi. The elaborately carved narrative reliefs on this pair are based on themes from the Latin poet Ovid's *Metamorphoses*.

On the chest at the right, under the Hobbema *Village with Water Mill among Trees*, the sun-god Apollo charms the animals with his music and pursues the reluctant nymph Daphne, who turns into a laurel tree to escape him. Now step over to the companion chest a few steps to your left. It depicts the fateful musical contest between the satyr Marsyas and Apollo, who was also god of music. At the right here, Marsyas is tied to a tree as Apollo inflicts the terrible punishment he has chosen for the loser of their musical contest—he flays the satyr alive. The skin of the satyr's torso lies beneath his upraised leg. Gruesome scenes like these were often painted on cassoni, but here they're sculpted in dark walnut, finished to look like bronze.

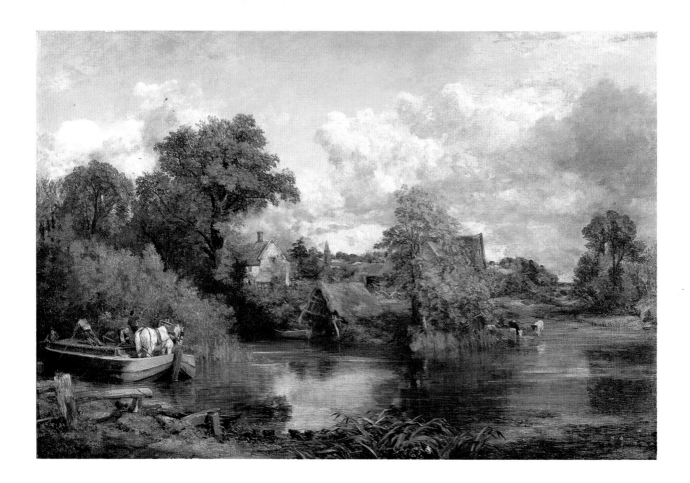

Constable

The White Horse

Oil, on canvas

51 ¾ × 74 ⅛ in. (131.4 × 188.3 cm)

Signed and dated: *John Constable,*
A.R.A. / London F. 1819

Acc. No. 43.1.147

In this wide expanse of canvas, nothing very remarkable occurs. To the left, a white tow horse is being ferried across the River Stour in Suffolk, at the point at which the path switches banks. To the right, cattle come down to the river's edge for water. A cluster of farm buildings is seen through trees, and in the foreground, a variety of plants and old wooden posts—all closely observed—are lovingly delineated.

The setting was intimately familiar to Constable, whose father owned and operated mills in nearby Dedham. It was such scenes, he later said, that "made me a painter." Yet it is not the subject matter *per se* but the freshness with which it is depicted that arrests our attention. Using a palette knife and brush, the artist applied paint in a variety of rough and smooth strokes and dots to suggest the shimmering of light filtered through clouds, and reflected on water and foliage. We can almost feel the moisture in the air.

The White Horse is the first of a number of paintings which Constable called his "six-footers." He painted them for display at the Royal Academy, working them up in the studio from sketches made on the spot. It was also one of his favorite paintings, which he bought back from its owner. As Constable noted, "There are generally in the life of an artist perhaps one, two, or three pictures, on which hang more than usual interest—this is mine."

Bronzino
Lodovico Capponi
Oil, on panel
45 ⅞ × 33 ¾ in. (116.5 × 85.7 cm)
Painted about 1550–5
Acc. No. 15.1.19

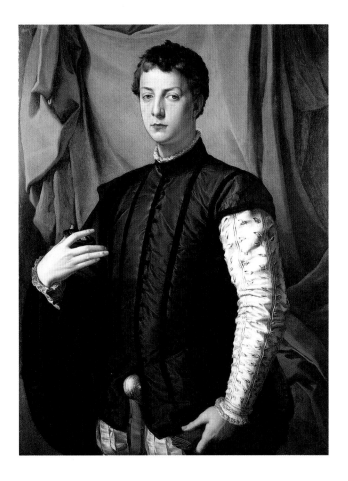

Agnolo Bronzino (1503–72)
*Agnolo di Cosimo di Mariano, called
Il Bronzino, was the court painter to
Duke Cosimo I de' Medici from 1539
to 1560. Like his teacher Jacopo
Pontormo, Bronzino executed mytho-
logical and religious frescoes, ephemeral
decorations, and tapestry designs for
the Florentine court. Bronzino is best
remembered, however, as the most
celebrated Florentine portrait painter
of the mid-sixteenth century.*

This elegant young aristocrat was Lodovico Capponi, a page at the Medici court in Florence. He wears his family's armorial colors of black and white. The index finger of his right hand partially conceals the cameo he holds, inscribed "sorte," or "fate"—an allusion to the obscurity of the future. The allusion is singularly appropriate. In the mid 1550s, the young Lodovico fell in love with a Florentine woman whom the Duke Cosimo de' Medici had intended for one of his cousins. Despite mounting pressure, the couple remained true to their love for nearly three years. Then, Cosimo abruptly changed his mind, allowing the marriage, but demanding that it occur within twenty-four hours.

Agnolo Bronzino, who painted this portrait, was court painter to that powerful Duke. His mannerist approach is evident in Lodovico's elongated torso, arm, and fingers, small head, and elaborately elegant dress. We're aware of every detail, from the puckerings of silk on the jacket, to the tiny slashings in the sleeve, the embroidered lace around the wrists, or the folds of that copious, rather ominous green drapery behind him. But Bronzino creates this fabulous illusion by leaving not the slightest evidence of his brush.

The young man wears a prominent codpiece that protrudes from the bottom of his jacket—a conceit considered part of masculine elegance at the time. Its sexual implications were so powerful that in the nineteenth century it was temporarily painted over.

Veronese

Allegory of Virtue and Vice
Oil, on canvas
86 ¼ × 66 ¾ in. (219 × 169.5 cm)
Painted about 1580
Acc. No. 12.1.129

Veronese

Allegory of Wisdom and Strength
Oil, on canvas
84 ½ × 65 ¾ in. (214.6 × 167 cm)
Painted about 1580
Acc. No. 12.1.128

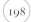

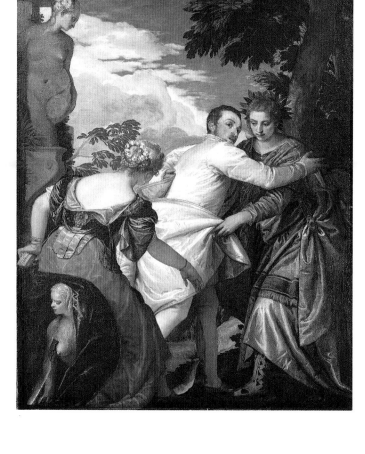

Veronese (Paolo Caliari) (1528–88)
Veronese began his artistic training in Verona, the town after which he is named. His religious, mythological, and allegorical frescoes and monumental canvases decorate many churches and villas in and around Venice. His only sojourn away from the Veneto came around 1560, when he made a brief trip to Rome.

All the splendor of Venetian color and light, of beautiful landscapes, skies, and people, of lustrous silks and jewels, are brought together in the Frick's two enormous canvases by Veronese. They have held their place of honor here since the gallery was installed in 1914.

On the left of the doorway, the artist has depicted the familiar subject of Hercules at the Crossroads, where he encountered Vice (seen from behind), who offered him a life of ease and pleasure, and Virtue, who showed him a rugged ascent leading to true happiness. Having favored Virtue, Hercules turns to avoid the angry claws of Vice. On the entablature at upper left appears the motto: "Honor and Virtue Flourish after Death."

To the right of the doorway hangs the complementary *Allegory of Wisdom and Strength*. Its inscription—legible at the base of the column at lower left—is familiar and clear: "All is Vanity." The theme stresses the supremacy of divine wisdom over worldly things, like the crown, scepter, and jewels scattered across the foreground. Veronese gives this concept riveting visual form in his design. Wisdom towers above Hercules, her noble stance contrasting with his sleepy slouch. Her brilliance casts him in shade. Wisdom looks up to a celestial light, while Hercules looks down on only earthly things.

No other painting in The Frick Collection can compete with the distinguished history of these two, which belonged to, among others, such famous collectors as the Emperor Rudolph II, Queen Christina of Sweden, the Duc d'Orléans, and the banker Thomas Hope.

Netherlandish
Triton and Nereid
Bronze
H. 25 ½ in. (64.8 cm)
Acc. No. 16.2.15

Giovanni Bologna, after
Triton Blowing a Trumpet
Bronze
H. 17 ⅜ in. (44.1 cm)
Acc. No. 16.2.44

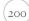

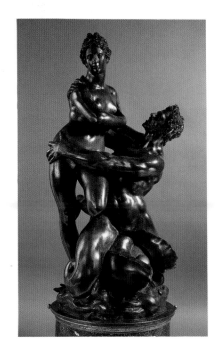

Hubert Gerhard
(1540/50–before 1621)
Born in the Netherlands, Gerhard may have studied in the Florentine workshop of Giambologna. By 1581 he was a practicing artist in Germany, producing terracotta and bronze figural compositions as well as monumental fountains.

Giovanni Bologna (1529–1608)
Giambologna was apprenticed to the Flemish sculptor Jacques Du Broeucq, who introduced him to the Italianate style. He traveled to Rome in 1550 to study classical sculpture and two years later settled in Florence. Giambologna became court sculptor to the Medici, for whom he executed grand allegorical and mythological compositions, equestrian statues, and fountains. His large workshop also produced bronze statuettes and religious narrative reliefs.

In 1916, Henry Clay Frick began to add sculpture to his collection, until then primarily celebrated for its paintings. Concerning his purchase of a group of Renaissance bronzes from the estate of banker and collector J. P. Morgan, the art historian John Pope-Hennessy declared: "What resulted was one of the finest collections of small bronzes...in the world."

For instance, at the left on this table is *Samson and Two Philistines* from a model by Michelangelo. Here, the mighty Samson raises the jawbone of an ass to strike one of the Philistines who taunted him, while another lies dead beneath his feet. According to the Old Testament, a thousand Philistines perished by his hand. The tautly entwined spiral of figures draws us around the sculpture—no single view shows the entire action.

This sculpture, a model for a monumental marble group that was never completed, elicited so much excitement that it was widely copied in many media. This one is considered the very best, as close as we can get to the work of the master himself.

The larger central bronze is attributed to the late sixteenth-century Dutch-born sculptor Hubert Gerhard, known for his fountains. We're not sure whether the half-man, half-fish Triton is embracing the impassive, heroic sea nymph or capturing her. His mouth gapes, perhaps in astonishment—but also because water would have gushed from it.

The third bronze on this table depicts a Triton astride three dolphins. It too may well have been part of a fountain complex. The twist of the figure's long, elegant torso as he raises a sinuous arm to play his seashell trumpet recalls the virtuoso style of the Renaissance master Giovanni Bologna.

Michelangelo, after
Samson and Two Philistines
Bronze
H. 14 ½ in. (36.7 cm)
Made probably in the mid sixteenth
century
Acc. No. 16.2.40

Michelangelo Buonarroti
(1475–1564)
*Michelangelo was an apprentice in
the workshop of Domenico Ghirlandaio
before training as a sculptor with
Bertoldo. For the Florentine circle of
Lorenzo de' Medici and his descendants
he executed many architectural and
sculptural commissions. Some of the
artist's most famous works were
executed in Rome, where he worked
intermittently for the papal court.*

Nardon Pénicaud

Double Triptych with Scenes from the Passion

Enamel, on copper

15 × 21 in. (38.9 × 53.3 cm)

Made in the first half of the sixteenth century

Acc. No. 16.4.3

(201)

The room in which you are standing was originally designed to serve as Mr. Frick's "office" or study. Visitors would have had to traverse the length of the adjoining West Gallery to reach it. Perhaps this was a bit too theatrical for Mr. Frick, or impractical, for early on, the room became a showplace for enamels and other precious objects, and the office was established at the opposite end of the West Gallery.

The adaptation took place in 1917, shortly after Mr. Frick acquired from the estate of J. Pierpont Morgan one of the finest collections ever formed of Limoges enamels—an art form of great splendor, much sought-after by important collectors of the nineteenth and early twentieth centuries.

The making of enamels goes back to antiquity, to Rome, Byzantium, and the Far East. All those displayed in this gallery were produced during the sixteenth and early seventeenth centuries in the city of Limoges, in central France. Basically, the technique involves the fusion under heat of a vitreous substance, like liquid glass, onto a copper plaque. The creators of these enamels depended primarily on graphic models—woodcuts and engravings—for their subjects and compositions.

Today this room contains Limoges enamels together with bronzes and timepieces from Renaissance France, Italy, and Germany. Originally produced for domestic use and display, these objects reveal the artistry and craftsmanship that was so highly valued by wealthy Renaissance merchants and nobles.

Gentile da Fabriano

Madonna and Child, with Sts.
Lawrence and Julian
Tempera, on panel
35 ¾ × 18 ½ in. (90.8 × 47 cm)
Signed: *gentili[s?]* [*de?*]
Painted about 1423–5
Acc. No. 66.1.167

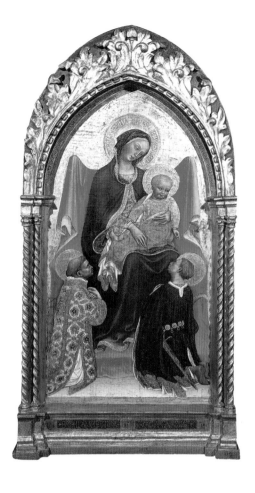

Gentile da Fabriano (*c.*1385–1427)
Born in Fabriano, in the Marches,
Gentile worked as a painter in Venice
and Brescia until he moved to Tuscany
in 1420. He later executed frescoes and
panel paintings of religious subjects in
the late Gothic manner for churches and
noble families in Florence, Siena, and
Orvieto. He also painted a fresco cycle
(now destroyed) for St. John Lateran in
Rome around 1427.

This splendid Italian altarpiece from the first quarter of the fifteenth century
actually survived in its original frame.

The panel depicts the *Madonna and Child* with two attendant saints
and was made probably for a private family chapel by the Florentine
master Gentile da Fabriano. The figures are painted in tempera over a gold
ground that has been worked with tools to create patterns in the borders
of the garments—around the Virgin's robe, for example, and in the halo
and clothing of the Christ child, who plays delightfully with a little bird on
a string, probably representing the soul. The technique is typical of early
Renaissance painting in Florence.

On the left is St. Lawrence, the third-century Roman deacon, who
kneels beside the gridiron on which he was roasted. This was the punishment
inflicted upon him for presenting the poor and the sick when the prefect
of Rome commanded him to hand over the treasures of the church. St.
Julian the Hospitaler, on the right, built a refuge for travelers to atone for
accidentally killing his parents. The faces of the saints are extraordinarily
individualized for this period.

Piero della Francesca

St. John the Evangelist
Tempera, on panel
52 ¾ × 24 ½ in. (134 × 62.2 cm)
Painted between 1454 and 1469
Acc. No. 36.1.138

Piero della Francesca,
or workshop
The Crucifixion
Tempera, on panel
14 ¾ × 16 ³⁄₁₆ in. (37.5 × 41.1 cm)
Painted probably between 1454 and 1469
Bequest of John D. Rockefeller, Jr.,
in 1961
Acc. No. 61.1.163

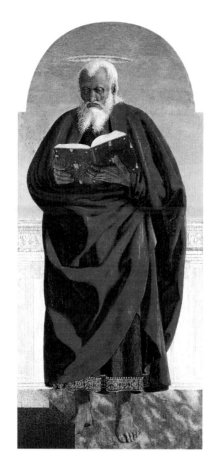

Piero della Francesca (*c.*1415–92)
Born in the Tuscan town of Borgo San Sepolcro, Piero trained in Florence with Domenico Veneziano. He executed narrative and devotional paintings in Rimini, Rome, Urbino, Borgo San Sepolcro, and Arezzo, where he painted his most famous fresco cycle, the Legend of the True Cross.

Dominating the Enamel Room is this tall, august figure of St. John the Evangelist painted by Piero della Francesca. In Mr. Frick's time, the taste for this artist had not fully declared itself; but The Frick Collection now presents four paintings by, or closely associated with, this revered Italian Renaissance master, all displayed in this room. The panel of St. John is one of Piero's few major works outside Italy. It's from an altarpiece, probably one of four depictions of saints that once flanked a central seated Virgin and Child. In the lower left corner here, you can see the base of the Virgin's throne.

This is one of the most arresting depictions of the early saints of the Church—this old man with his white beard and white hair, beautiful feet and hands, and majestic toga-like garment. And the ornamentation of his robe, set with jewels and pearls and gold filigree, is such a strange and marvelous contrast to the homely realism of his bare feet.

The three other works here, either by or closely associated with Piero, are thought to be from the same altarpiece. To the left, the small yet monumental panel of the *Crucifixion* may have formed part of its base and was bequeathed by John D. Rockefeller, Jr.

And if you turn around and look to the right of the doorway, you'll find two more small panels by Piero. They depict a nun and monk—both rather sour-looking—wearing the dark gray habits of the Augustinian order.

Duccio

*The Temptation of Christ
on the Mountain*
Tempera, on panel
17 × 18 ⅛ in. (43.2 × 46 cm)
Painted between 1308 and 1311
Acc. No. 27.1.35

(206)

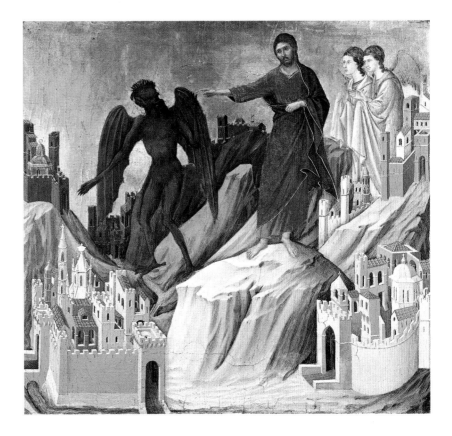

Duccio di Buoninsegna
(*c.*1255–1319)
*Very little is known about this leading
Sienese artist, who is first noted in a
document of 1278. Duccio's most famous
work is the* Maestà, *a large double-
sided altarpiece painted for the Duomo
of Siena between 1308 and 1311.*

This precious panel originally formed part of a large altarpiece called the
Maestà, or "The Majesty," that was carried in triumph through the streets
of Siena on June 9, 1311. Painted nearly seven hundred years ago, it is the
oldest work of art in The Frick Collection. Although the artist—Duccio
di Buoninsegna—is recognized as one of the most innovative masters of the
early Renaissance, practically nothing is known about him.

 This is one of the altarpiece's many scenes illustrating the life of Christ.
It depicts, with great precision, his encounter with the devil as recounted
by Matthew: "...the devil took him to a very high mountain, and showed
him all the kingdoms of the world in their glory. 'All these,' he said, 'I will
give you, if you will only fall down and do me homage.' But Jesus said,
'Begone, Satan! Scripture says, "You shall do homage to the Lord your God
and worship him alone."' Then the devil left him; and angels appeared and
waited on him."

 In typical medieval fashion, Duccio depicts as though occurring
simultaneously Jesus dismissing the devil and the angels who appeared later.
His Christ has the nobility of ancient sculpture; his devil, the creepiness
of a nightmare. The kingdoms of the world—packed with towers, domes,
and crenelations—look like marzipan confections, tempting indeed!

 If you look very closely at the devil's face, you will see scratches left
from an early attempt to mutilate it—an act that suggests its magic power.

Paolo and Giovanni Veneziano
The Coronation of the Virgin
Tempera, on panel
43 ¼ × 27 in. (110 × 68.5 cm)
Signed and dated: M.C.C.C.L.V.I.I.I. /
PAVLVS CVM / IOHANINVS IEV / FILIV /
PISERVTHOCOP
Acc. No. 30.1.124

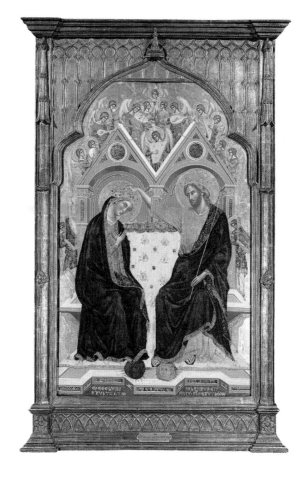

Paolo and Giovanni Veneziano
(Paolo, active 1321–58)
*Paolo was the leading figure in
Venetian fourteenth-century painting.
He ran an active workshop, in which
his brother Marco and sons Luca and
Giovanni were also trained. Relatively
little is known about Giovanni's life,
besides his collaboration with his father
on the Pala d'Oro cover for San Marco,
Venice, and The Frick Collection's*
Coronation of the Virgin.

This *Coronation of the Virgin* delights musical historians because of its very accurate depiction of various fourteenth-century musical instruments played upon by an angelic choir, symbolizing the harmony of the universe.

On either side of the heavenly throne, behind the main figures, standing angels play portable organs, while above the throne, at the far left, the first angel strikes a tambourine. At the left peak of the throne, another plays a bladder-pipe. At the top center, three angels sing, and, just below them, an angel in blue stripes plucks a psaltery.

The heavenly choir is there, of course, to glorify the main subject—the apocryphal Coronation of the Virgin, who bows her head as her triumphant son crowns her Queen of Heaven. Beneath the Virgin's feet is the moon. Symbolizing chastity, it had been associated with her from early times, just as the sun—here beneath Christ's feet—had been equated with him. Along the base of the throne, the inscription repeats the first two lines of the sung responses at Eastertide known as "Regina coeli," or "Queen of Heaven."

This picture is the last dated work by the leading fourteenth-century Venetian artist Paolo Veneziano, done in collaboration with his son Giovanni. Its splendid surface—richly patterned textiles, brilliant pinks and reds, and the sheer quantity of its gold leaf—make it one of the most sumptuous paintings to have come down to us from the Italian Renaissance.

Vecchietta
The Resurrection
Bronze
21 ⅜ × 16 ¼ in. (54.3 × 41.2 cm)
Signed and dated: OPVS.LAVR /
ENTII.PETRI.P / ITTORIS.ALS / VECHIETTA.
/ DE SENIS.M. / CCCC.LXXII
Acc. No. 16.2.2

Algardi
Pietà
Bronze relief (octagonal)
Excluding flange: 11 ¾ × 11 ¾ in.
(29.8 × 29.8 cm)
Made probably in the 1630s
Purchased with funds from the bequest
of Arthemise Redpath in 1992
Acc. No. 92.2.99

210

Vecchietta (Lorenzo di Pietro)
(before 1410–80)
*Vecchietta was active in Siena after
1428 as a sculptor, fresco and panel
painter, and fortifications expert. While
his early sculpture was executed prima-
rily in wood, his later work in bronze
shows the influence of Donatello, who
was in Siena between 1457 and 1459.*

Alessandro Algardi (1598–1654)
*Algardi began his studies at Ludovico
Carracci's Accademia degli Incaminati
in Bologna and later trained with
the Emilian sculptor Giulio Cesare
Conventi. Around 1622 he entered the
service of Duke Ferdinando Gonzaga
in Mantua, and three years later he
worked as a sculptor and restorer for
Cardinal Ludovico Ludovisi in Rome.
Competing with Bernini for patrons,
Algardi executed monumental religious
compositions, portrait busts, and
architectural projects for Pope Innocent X
and his family.*

The Resurrection, one of the finest relief sculptures of the Italian Renaissance, is the only fully authenticated small bronze by Vecchietta known. Here, the influential fifteenth-century Sienese artist blends medieval conventions such as arbitrary scale and skewed perspective with classical details in the sarcophagus and the armor. He must have been proud of his achievement, for he inscribed on it his name and the date 1472.

This late work, possibly made as the door to a tabernacle, shows Christ floating up in a cloud of adoring angels. The soldiers guarding him are depicted in tortured sleep, sprawled across the foreground, rendered in meticulous detail that grounds this intensely spiritual apparition in physical reality. The fact that the soldiers seem to be spilling out of the frame lends even greater drama to the figure of Christ, which is almost completely separated from the background.

To the right, in the relief closest to the door, we find similar devices at work in another religious scene—this time the *Pietà*. It was done some 150 years later by Alessandro Algardi, who, along with Bernini, was one of the great masters of Italian baroque sculpture, working primarily in Rome. Here, Algardi makes total use of the available space to heighten the pathos of the moment. The right arm of the Virgin juts out in a classic gesture of despair as she lifts the shroud to reveal the body of her dead son, almost swooning with emotion. The mood here is more lyrical than in the Vecchietta, with refined, elegant gestures and billowing, almost otherworldly, drapery.

The *Pietà* was purchased for The Frick Collection in 1992 through the generous bequest of Arthemise Redpath.

David

The Deposition

Oil, on linen, mounted on panel

56 ⅛ × 44 ¼ in. (142.5 × 112.4 cm)

Painted about 1510–15

Acc. No. 15.1.33

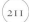

211

Gerard David (active 1484–1523)
*By 1484 David had moved from his
native Oudewater to Bruges, where he
flourished as the city's chief painter. His
religious paintings show the influence of
the Flemish artists Hugo van der Goes
and Memling. David received commis-
sions from local churches, monasteries,
and other religious institutions, as well
as from private foreign patrons.*

This early sixteenth-century depiction of the removal of Christ's body from
the cross is one of the first known paintings in oil on canvas from Northern
Europe. By employing the oil medium rather than traditional water-based
tempera, the Flemish artist Gerard David was able to achieve a remarkably
subtle range of cold, but vibrant, hues. The paint surface was transferred
to a wood panel in the early twentieth century.

David depicts the grieving figures with characteristic dignity and
restraint. Mary Magdalene, at the right, holds the nails of the Crucifixion.
Next to her, Nicodemus supports Christ's legs, while the disciple Joseph of
Arimathea, on the ladder, holds his body. At the far left, St. John, tears
streaming down his face, supports the grieving Virgin. In the foreground,
a broken skull and scattered bones add a dramatic note to the austere and
measured composition. Almost surreal in their finely rendered details, they
heighten the sense of stillness with eerie, ominous beauty.

Above, the darkness which was said to envelop the world at Christ's
death is lifting, merging into gray clouds and a clear sky at the horizon. But
for all David's meticulous devotion to the traditional story, he can't resist
adding a reference to his own world. Above the weeping Mary Magdalene,
on the right, is a tiny windmill straight out of the Netherlands.

Rembrandt

The Polish Rider
Oil, on canvas
46 × 53 ⅛ in. (116.8 × 134.9 cm)
Signed: *R[e?]*
Painted about 1655
Acc. No. 10.1.98

Rembrandt Harmensz. van Rijn
(1606–69)
*Rembrandt was born in Leyden, stud-
ied there with Jacob van Swanenburgh,
and later moved to Amsterdam to work
with Pieter Lastman. He returned to
Leyden for about five years before set-
tling permanently in Amsterdam around
1631–2. The subjects of Rembrandt's
paintings, drawings, and etchings
include religious and historical scenes as
well as individual and group portraits.*

One of the most famous and most beloved paintings in The Frick Collection, Rembrandt's *The Polish Rider* offers the ultimate allure: mystery.

For instance, is this a portrait or a depiction of a character from history or literature? Equestrian portraits are rare in Dutch art of the seventeenth century and usually depict a rider in fashionable dress astride a well-bred horse, not a skeletal wreck like this one. Since the costume and weapons seem genuinely Polish, and the young man's handsome face has a Slavic character, authorities today are inclined to interpret the subject as an idealized depiction of one of the brave Polish cavalrymen whose exploits stirred the Dutch imagination during the 1650s.

An even more serious mystery is: did Rembrandt really paint *The Polish Rider*? For a number of years this question has hung over the painting, but a more recent consensus suggests that Rembrandt, indeed, conceived the subject, and painted its finest passages, such as the face of the rider, the head and neck of the horse, the harness, the weapons, and the broad outlines of the landscape. Then, in order to make the unfinished painting saleable during the artist's bankruptcy in 1656, it is suggested that an unknown assistant stepped in to finish the canvas, contributing such weaker areas as the horse's legs, and the weak construction of the hands, especially the right one clasping the war hammer.

And yet, perhaps because of these baffling questions, *The Polish Rider* continues to enthrall all those who stop before it.

Hals
Portrait of a Man
Oil, on canvas
44 ½ × 32 ¼ in. (113 × 81.9 cm)
Signed: FH
Painted about 1660
Acc. No. 17.1.70

Hals
Portrait of a Painter
Oil, on canvas
39 ½ × 32 ⅝ in. (100.3 × 82.9 cm)
Painted probably in the early 1650s
Acc. No. 06.1.71

(217)

Frans Hals (1581/85–1666)
Born probably in Antwerp, Hals moved with his family to Haarlem by 1591. He probably studied there before 1603 with Karel van Mander and joined the Haarlem painters' guild in 1610. Hals was primarily known as a genre and portrait painter to private middle-class patrons, but he also executed group portraits for militia companies and charitable institutions.

Frans Hals was a contemporary of Rembrandt, but is seldom thought of in the same league. Mr. Frick had a great fondness for Hals, and the four paintings by him here in the West Gallery provide a rare opportunity for anyone who wants to appreciate his work.

Hals took obvious delight in this great honest figure of a man, painted when the Antwerp-born artist was well over seventy. His clients were mainly prosperous burghers from Haarlem, where he worked for most of his career. The thriving city's main industry was beer, and this unidentified man looks as though he's been drinking it most of his life.

The portrait is painted with extraordinary directness and swiftness. Look at the great bursts of white drapery coming through the fashionably slashed sleeves. Hals has a wonderful time with those triangles of white and gray, improvising brilliantly with his brush like a great pianist on the keys. The glove the man is holding is just sketched in with a few joyful strokes. This self-confident, abbreviated way of representing forms would be greatly admired by artists such as Manet in the nineteenth century.

A few steps to the left is Hals' *Portrait of a Painter*. Here, he has chosen a momentary pose, the man's arm resting on the back of his chair.

If you walk across the gallery now, to the long wall opposite, you'll find Hals' animated technique again in two more portraits—the *Portrait of a Woman* and the *Portrait of an Elderly Man*. In the man, perhaps the finest of all these paintings, Hals' brushwork makes you very much aware of the act of painting—as in that crucial shadow barely indicated on the right side, or the highlights on the outstretched right arm.

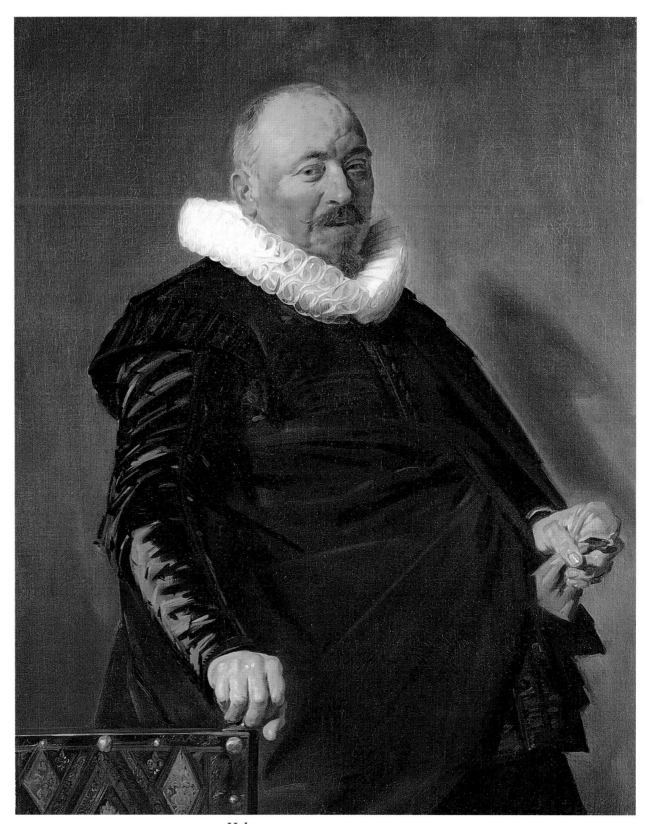

Hals

Portrait of an Elderly Man
Oil, on canvas
45 ½ × 36 in. (115.6 × 91.4 cm)
Painted between 1627 and 1630
Acc. No. 10.1.69

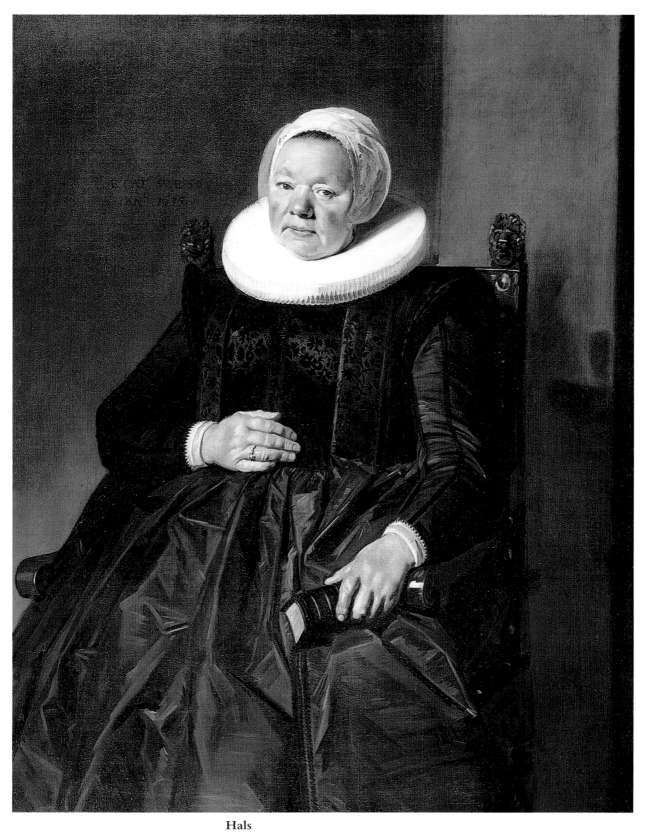

Hals

Portrait of a Woman
Oil, on canvas
45 ⅞ × 36 ¾ in. (116.4 × 93.3 cm)
Inscribed: AETATAE SVAE 56 / ANO 1635
Acc. No. 10.1.72

La Tour

The Education of the Virgin
Oil, on canvas
33 × 39 ½ in. (83.8 × 100.4 cm)
Signed: *de la Tour f.*
Painted about 1650
Acc. No. 48.1.155

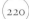

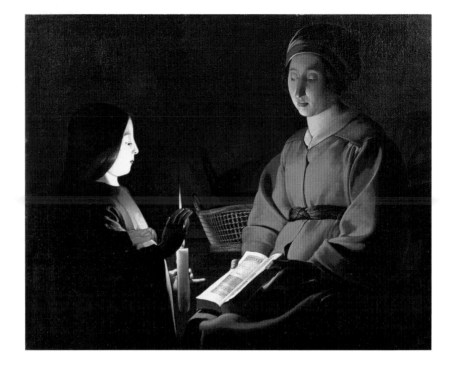

Georges de La Tour (1593–1652)
*La Tour spent much of his life in
Lunéville, a small town in Lorraine.
His dramatic religious and genre
paintings may have been influenced by
Caravaggio or his Dutch followers,
whose works were popular in Lorraine.
La Tour was often assisted by his son
Étienne (1621–92), who abandoned his
career as a painter seven years after his
father's death.*

This vivid night scene depicts the young Virgin Mary being taught to read by her mother, St. Anne. The candle is virtually a signature of the seventeenth-century French painter Georges de la Tour. Here, its flame glows through the child's hand—a hand so vividly observed that, if you look closely, you'll see that the fingernails are dirty.

The figure of St. Anne is better preserved than that of the Virgin, whose doll-like face has been much abraded through aggressive restorations over the years. Still, the picture packs a wallop, particularly in the rich orange-brown harmonies of St. Anne's gown and turban, and the basket in the center background.

La Tour was hardly known in Mr. Frick's day, and this picture was not bought until 1948. Following the artist's death in 1652, his work fell into obscurity, only to be rediscovered after World War II, when its striking, pared-down design proved very appealing to mid twentieth-century sensibilities. La Tour's relatively limited oeuvre has since inspired much debate, particularly since many of his works exist in studio replicas. It is not known, for instance, whether this picture is a copy of a lost original painted during the artist's lifetime, perhaps by his son Étienne, or a badly preserved autograph work.

Rembrandt
Self-Portrait
Oil, on canvas
52 ⅝ × 40 ⅞ in. (133.7 × 103.8 cm)
Signed and dated: *Rembrandt / f. 1658*
Acc. No. 06.1.97

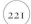

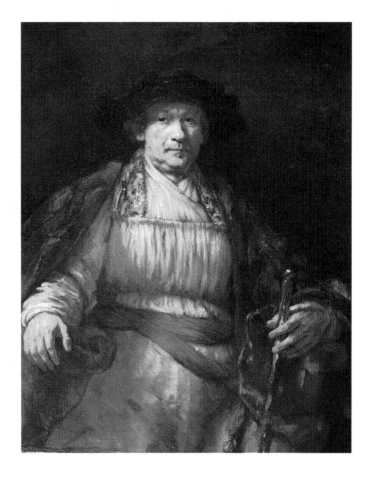

Of the many self-portraits Rembrandt painted over a lifetime, this is perhaps the ultimate one, not only for its poignant revelations of the self, but for its painterly magnificence. It gleams as though made of gold, and its rugged paint surfaces suggest the artist might have mixed crushed jewels with his pigments.

The initial effect upon viewers is daunting, as though we were confronting an ill-tempered monarch or a very rich grandfather displeased with our conduct. The strange outfit he wears is beyond time, like a priest's vestments. In place of a crown, a large velvet beret floats over his head like a cloud at night. He fingers a staff as though it were a scepter. Yet this feeling of an uneasy confrontation diminishes as we study the face. The wariness and impatience seem like a veil shadowing the man's real face, which is blurred and scarred—by time, by sorrows, and illness. Yet Rembrandt was only fifty-two when he signed and dated this portrait. He was also a small man, but he portrayed his figure in monumental dimensions. It is almost as though he decided to pack his entire life into this image of himself, both what had gone before, and what lay ahead.

The gigantic hands that loom before us are crucial to the portrait's effect, reminding us of Rembrandt's profession as an artist. They, after all, are the physical instruments with which he created this grand illusion, and so many others.

Vermeer

Mistress and Maid

Oil, on canvas

35 ½ × 31 in. (92 × 78.7 cm)

Painted probably between 1665 and 1670

Acc. No. 19.1.126

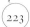

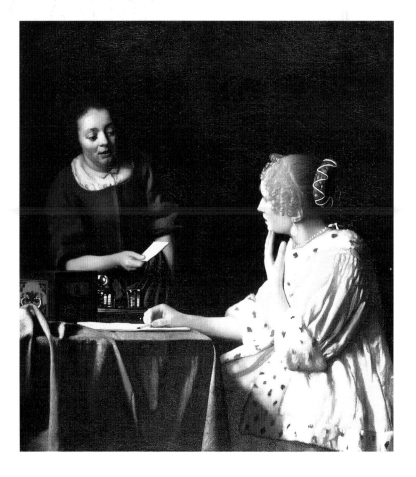

Although the subject of writing and receiving letters recurs frequently in Vermeer's work and that of his contemporaries, rarely does it attain the level of dramatic tension so riveting here. Caught in a moment of mysterious crisis, the two women offer us viewers all sorts of scenarios to consider. Class distinctions are easily interpreted, as we note the sumptuous garments and jewelry of the mistress, as well as her elaborate coiffure, that contrast so strongly with the simplicity of the maid. Yet, psychologically, we intuit the sharing of private and perhaps illicit information that characterizes such an age-old relationship as that between a mistress and her maid, and which makes them, in a sense, equal.

Apart from the drama—and there is often drama in Vermeer's paintings—the pure formal beauty that we associate with his work even more strongly is present here in abundance, even though the picture appears unfinished. Observe the lack of modeling in the mistress' head and hair (both seem slightly blurred), the paw-like hand of the maid, and the relatively plain brown background. Yet Vermeer seldom if ever surpassed the subtly varied effects of light seen here as it softly envelops the figure of the mistress in a golden aureole, as it gleams almost electrically from her pearl jewelry and sparkles from the glass and silver objects on the table.

Bought by Mr. Frick in 1919, the year of his death, this painting was his last purchase and confirms unquestionably his evolution as a connoisseur.

Velázquez
King Philip IV of Spain
Oil, on canvas
51 ⅛ × 39 ⅛ in. (129.8 × 99.4 cm)
Painted in 1644
Acc. No. 11.1.123

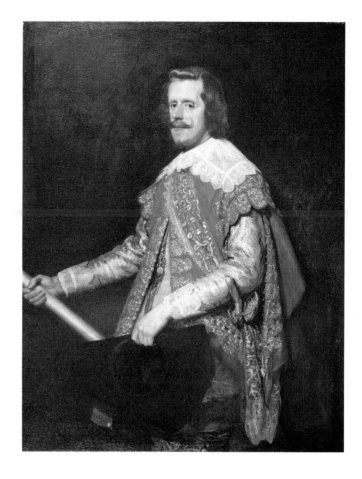

Diego Rodríguez de Silva y
Velázquez (1599–1660)
*Velázquez was born in Seville, where
he worked as apprentice to the painter
Francisco Pacheco. He went to Madrid
in 1623 to paint a portrait of King
Philip IV, who subsequently made him
his court painter. Velázquez made
two trips to Italy, one in 1629–31 and
another in 1649, and was probably
also influenced by the Flemish artist
Peter Paul Rubens, who visited Madrid
in 1628–29.*

Philip IV of Spain was known more for his lavish patronage of the arts than his military prowess, but on May 15, 1644, he led his troops to an important victory over the French at the Catalan town of Lérida. His entourage included Velázquez, his court painter and close friend. At the nearby town of Fraga, Philip posed for this portrait—now called the "Fraga Philip"— in the elaborate costume that he wore during the campaign. The makeshift studio was dilapidated, its floor strewn with reeds; Velázquez had to fling open a window to get enough light to paint by.

Velázquez' masterful technique is evident here everywhere—giving a somewhat summary description, but with total control of the brush. The brilliant rose tunic, with its silvers, whites, and grays, stands out against the plain umber background—extraordinary color harmonies, unique to Velázquez.

There's also a characteristic rigor to the composition that is very appealing to modern viewers. The geometrical forms of the hat and the bold line of the staff in Philip's hand seem almost like abstract elements set against the elaborate details of his clothing. And then there's that extraordinarily face: totally regal, totally believable. This is one of the greatest portraits of all time.

There are relatively few works by Velázquez outside Spain, and to buy a fully documented portrait of the King was a tremendous achievement— in fact, this is one of the most expensive and important paintings Henry Clay Frick ever acquired.

El Greco
Vincenzo Anastagi
Oil, on canvas
74 × 49 ⅞ in. (188 × 126.3 cm)
Signed in Greek characters
Painted about 1571–6
Acc. No. 13.1.68

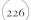

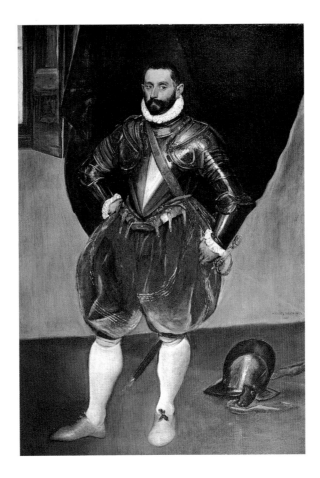

We tend to think of El Greco as a painter of religious subjects, which he concentrated on almost exclusively after he settled in Spain around 1577. But this painting was done a few years earlier, during the Greek-born master's last years in Italy. There, he had studied with the celebrated Titian in Venice, then moved to Rome. The authoritative figure before us is the Italian military leader Vincenzo Anastagi, a member of the prestigious Knights of Malta, and a hero in the defense of that island during the massive Turkish siege of 1565. An expert in fortifications, Anastagi later became Sergeant Major of the great Roman fortress, Castel Sant'Angelo.

The rather stocky build of this powerful man dressed in armor with his muscular legs gives no hint of the strange, elongated proportions El Greco began using in Spain, but the portrait is characteristically spirited and intense. We have a vivid sense of a spacious but spartan interior, with its draped wall, open window, and bare floor with his helmet resting on it.

From the hilt of Anastagi's sword to the right edge of the painting is a diagonal line. It's a prime example of a pentimento—a ghostly image of something painted over that has begun to show through over the years as the top layer of paint becomes more transparent. Once, Anastagi's sword pointed directly to El Greco's signature in Greek characters at the bottom of the wall.

Incidentally, this is among the few paintings Mr. Frick ever sent out on loan; it was shown at the Knoedler Gallery in 1915 at an exhibition of works by Goya and El Greco. Mr. Frick stipulated in his will that nothing in the Collection should ever leave the building. The only works of art that have been loaned since then are ones purchased after his death.

Goya
The Forge
Oil, on canvas
71 ½ × 49 ¼ in. (181.6 × 125.1 cm)
Painted about 1815–20
Acc. No. 14.1.65

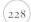
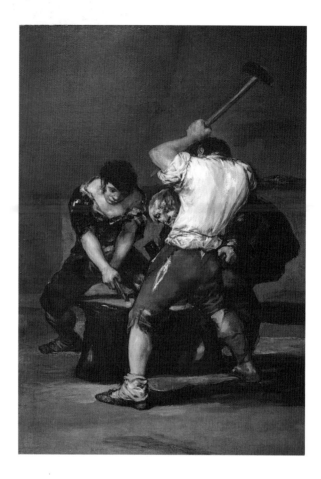

According to his daughter Helen, Mr. Frick collected pictures "that were pleasant to live with." A glance down the long gallery confirms this. But Goya's *The Forge*, with its pervasive darkness, vigorous brushstrokes, and proletarian subject, disrupts the serenity of its surroundings with a harsh realism. The size of this painting—normally reserved for religious or mythological scenes—endows the image of backbreaking labor with a sense of monumentality. In composition, the work evokes the traditional depictions of the forge of Vulcan, here updated to the gritty reality of modern industrial Europe. For the steel magnate Frick, the subject of this Spanish masterpiece must have had strong resonance.

Little detracts from the raw power of the three workers arranged in a pyramidal composition around a red-hot sheet of molten steel. The gestures of the smiths complement one another. The energy of the figure closest to us rises upward from a powerful base of muscular legs through the hoisted arm and sledgehammer. His counterpart bows downward and forward, holding the sheet in place with tongs. A stooped old man, holding bellows, juts in between the two young men—a grim reminder of the inexorable toll of time and unrelenting labor.

Goya painted this canvas in the beginning of his introspective "black period." The paint is laid on quickly in broad strokes with a crude power and vitality that underlies the expression of the work as a whole. Note the absolute sureness and abandon with which he painted the sock of the foreground figure!

Pietro Tacca, attributed to
Nessus and Deianira
Bronze
H. 34 ¾ in. (88.3 cm)
Acc. No. 15.2.49

Grupello
Eve
Bronze
H. 19 ³/₁₆ in. (48.7 cm)
Made in probably about 1700–5
Acc. No. 16.2.60

Sangallo
St. John Baptizing
Bronze
H. 20 ⅞ in. (53.1 cm)
Inscribed: FRANC S. GALLO / FACIE
Made probably between 1535 and 1538
Acc. No. 16.2.41

(230)

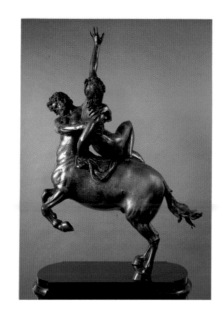 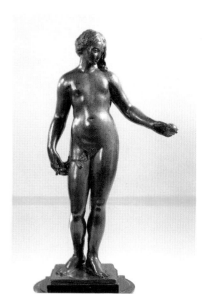

Gabriel Grupello (1644–1730)
*Of Milanese heritage, Grupello
was born in the Netherlands, where
he trained with Artus Quellinus I
in 1658–59. He became court sculptor
to various European dignitaries.*

Francesco da Sangallo (1494–1576)
*This painter and sculptor received his
early training from his father and later
collaborated with Michelangelo on
the New Sacristy of San Lorenzo in
Florence. Francesco specialized primarily
in relief and freestanding sculpture.*

The dramatic bronze in the center of this table is as carefully choreographed as a ballet, modeled after a famous bronze group by Giovanni Bologna, who was considered one of the greatest masters of the Italian Renaissance. It depicts the centaur Nessus abducting the terrified wife of Hercules, after offering her a ride across a turbulent river. The piece, resting on those two hind legs, is a magnificent achievement of delicately balanced counterforces typical of Bologna. This replica may have been made by Pietro Tacca, one of the most gifted sculptors in Bologna's successful workshop.

At the right end of the table, you'll find a marked contrast in the humble figure of *St. John Baptizing*, depicted with great humanity. This is the only known signed bronze by the sixteenth-century Florentine Francesco da Sangallo, who worked primarily in marble. Originally placed above a baptismal font, John the Baptist pours water from the cup in his outstretched hand. The heightened realism of his sorrowful face and spare body and the varied textures—from the saint's knotted locks of hair, sinewy neck, and massive, vigorous feet, to the rough animal hide and luxuriant fleece he wears as a makeshift tunic—all add up to a work of extraordinary power.

At the other end of the table is a beautiful *Eve* by the relatively little-known Netherlandish sculptor Gabriel Grupello, who worked at the end of the seventeenth century. The first woman holds one apple in her outstretched hand, and presses another against her thigh—a pose probably inspired by a well-known print of the *Fall of Man* by Albrecht Dürer. Eve's elegance, grace, and beauty are an effective counterpart to the heroic male figures that dominate the rest of this room.

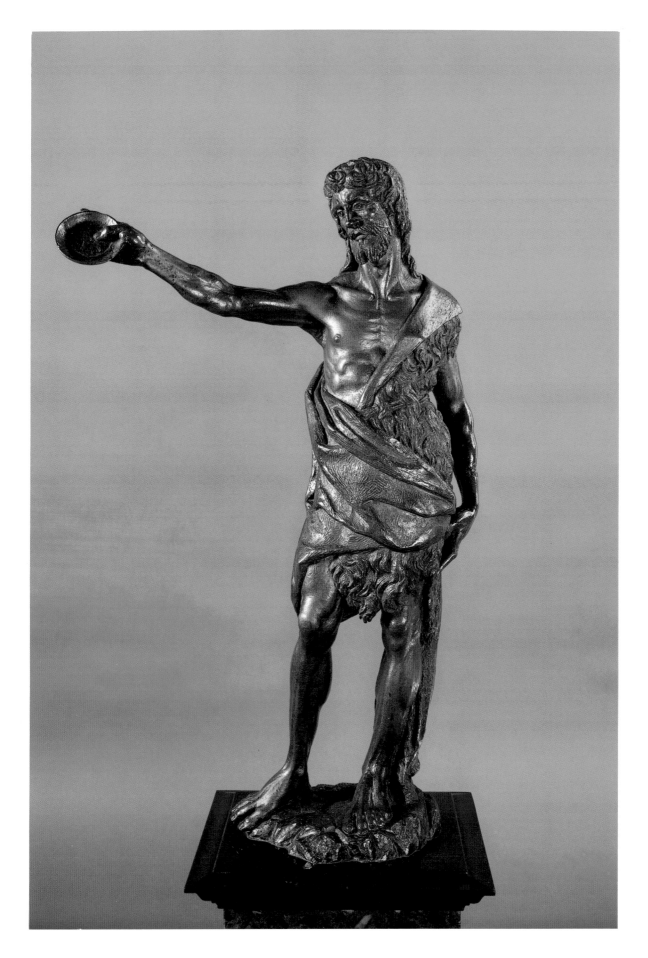

Van Dyck

Sir John Suckling

Oil, on canvas

85 ¼ × 51 ¼ in. (216.5 × 130.2 cm)

Painted between 1632 and 1641

Acc. No. 18.1.44

Van Dyck

The Countess of Clanbrassil

Oil, on canvas

83 ½ × 50 ¼ in. (212.1 × 127.6 cm)

Painted probably in 1636

Acc. No. 17.1.37

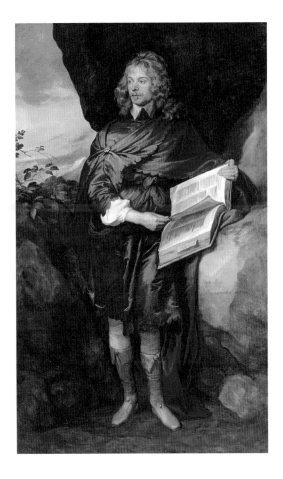

The four portraits displayed here illustrate two of the greatest phases of portrait painting: Sir Anthony Van Dyck's invention in the seventeenth century of a mode of presenting subjects full-length, wearing splendid clothing, and depicted standing in a natural setting, and Thomas Gainsborough's re-use of the same concept in the eighteenth century, done intentionally in homage of the earlier artist.

Van Dyck's invention broke with the traditional way of portraying people in lavish architectural settings. It gave a greater sense of reality to his subjects, even if to modern eyes they look a bit like hitchhikers. Gainsborough followed him so closely that he even dressed the *Hon. Frances Duncombe*, in the panel at the right of the doorway leading to the Garden Court, in a dress with slashed sleeves and gathered skirts that was more typical of Van Dyck's day than of his own.

If you stand in the center of the room, facing Houdon's *Diana*, the gentleman to your left—painted by Van Dyck in stage dress, holding a volume of Shakespeare open to Hamlet—was *Sir John Suckling*, a colorful poet, soldier, and statesman. To your right appears the *Countess of Clanbrassil*, an elegant lady from the court of Charles I. If you now turn and face the Garden Court, you see to your left *Mrs. Peter William Baker*, painted by Gainsborough in 1781, and, to your right, the ravishing *Frances Duncombe*, painted by him about five years earlier.

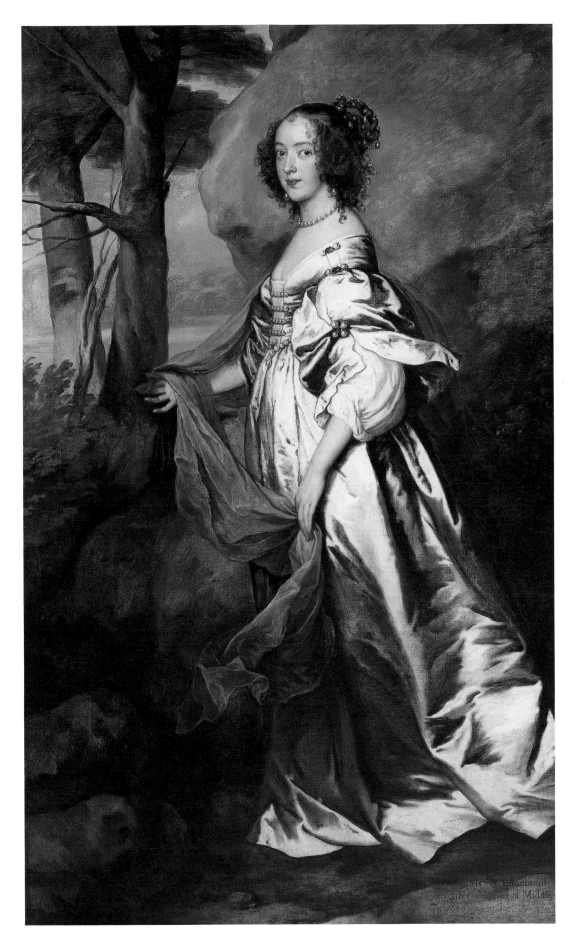

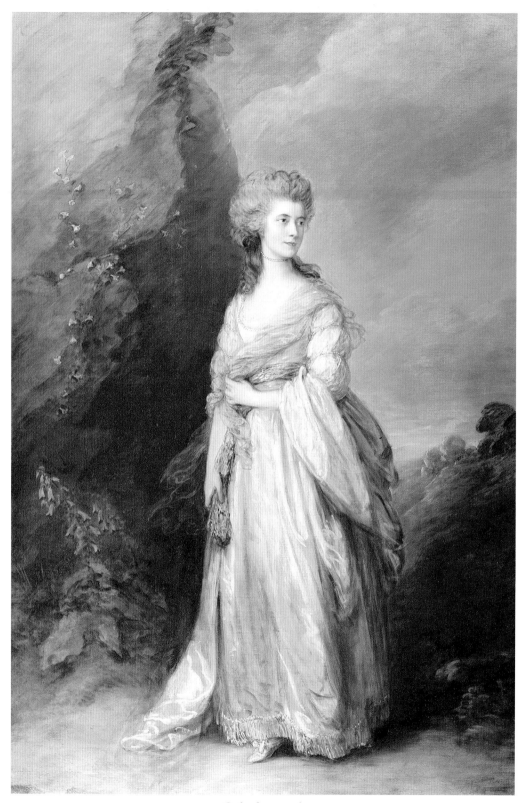

Gainsborough

Mrs. Peter William Baker
Oil, on canvas
89 ⅝ × 59 ¾ in. (227.6 × 151.8 cm)
Signed and dated:
Thos. Gainsborough / 1781
Acc. No. 17.1.59

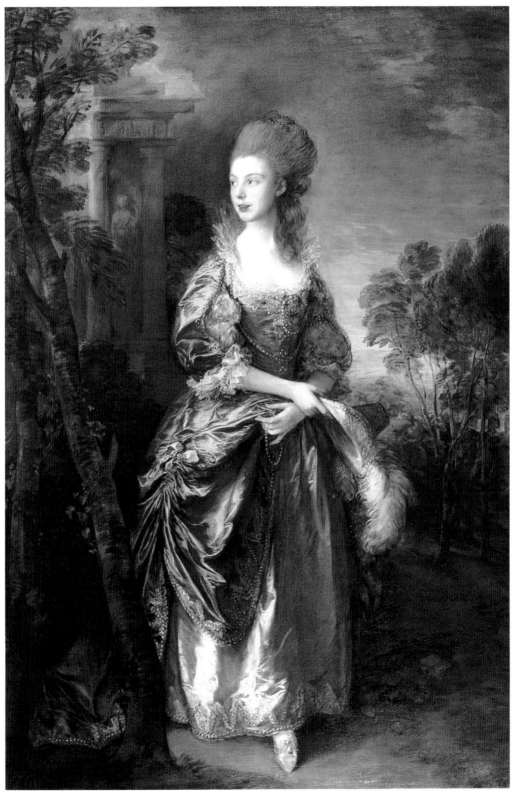

Gainsborough

The Hon. Frances Duncombe
Oil, on canvas
92 ¼ × 61 ⅛ in. (234.3 × 155.2 cm)
Painted about 1777
Acc. No. 11.1.61

Houdon

Diana the Huntress

Terracotta

H. overall 75 ½ in. (191.8 cm);
H. of figure 68 ⅛ in. (173 cm)

Inscribed: HOUDON *Scult*

Made probably between 1776 and 1795

Acc. No. 39.2.79

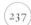

Here, poised on the ball of one foot, is Jean-Antoine Houdon's *Diana*—goddess of the hunt and the moon. Most terracotta figures are about twelve inches high. One of this size is a true phenomenon—few were made and even fewer have survived to the present. The construction was a real tour de force, involving at least ten separate clay sections, each fired individually. X-rays reveal that metal armatures were inserted within the arms, between the head and neck, and linking the foot to the base—but oddly, they do not interconnect. When the pieces were joined, the seams were concealed with clay, and the entire figure painted in flesh tones.

The nakedness of this regal goddess—without even a wisp of concealing drapery—is unusual in The Frick Collection. To Houdon's contemporaries, such a bold display of female sexuality seemed shocking. In fact, when his marble version of this statue was shown at the Salon of the Académie Royale, the only person who had the courage to buy it was Catherine the Great—typical of her!

For all her nudity, the chaste Diana remains icy and aloof—an effect achieved in part by her smoothly simplified and elegant body, and reinforced by her haughty expression and blank eyes, recalling ancient classical sculpture. Indeed, the figure brings several well-known classical Dianas to mind, as well as the *Apollo Belvedere* and Giovanni Bologna's *Mercury*, also balanced precariously on one foot. So Houdon was paying homage here to a tradition of grandiose nude sculpture—and, in the process, creating a masterpiece worthy of its antecedents.

Whistler

Symphony in Flesh Color and Pink:
Portrait of Mrs. Frederick Leyland
Oil, on canvas
77 × 40 in. (195.9 × 102.2 cm)
Signed with the butterfly monogram
Painted in 1872-3
Acc. No. 16.1.133

Whistler

Harmony in Pink and Gray:
Lady Meux
Oil, on canvas
76 × 36 in. (193.7 × 93 cm)
Signed with the butterfly monogram
Painted in 1881
Acc. No. 16.1.133

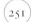

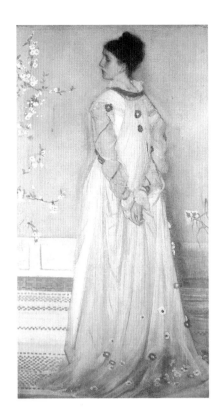

James McNeill Whistler
(1834–1903)
Born in Lowell, Massachusetts, and
educated briefly at West Point Military
Academy, Whistler spent much of his
life abroad. In 1856 he settled in Paris,
where he became an associate of French
artists and later exhibited his work at
the Salon des Refusés of 1863. In that
year, Whistler moved to London, which
would remain his home for most of
his life. In addition to his atmospheric
cityscapes and portraits, to which he
gave musical titles, Whistler achieved
lasting fame as a printmaker.

The expatriate James McNeill Whistler, regarded as an international figure
by the early years of the twentieth century, was the only American artist
Mr. Frick deemed worthy of his future museum—except for Gilbert Stuart,
chosen for his patriotic portrait of *George Washington*. Mr. Frick's collection
of Whistlers established him as a connoisseur of contemporary art.

The titles of the paintings on either side of this doorway—at the right,
Symphony in Flesh Color and Pink, and at the left, *Harmony in Pink*
and Gray—suggest Whistler's preoccupation with the formal side of painting.
Suggestive of music, they emphasize that likenesses were less important to
him than design—the arrangement of line, form, and color.

To the right of the doorway is Whistler's portrait of *Mrs. Leyland*, the
wife of Liverpool shipping magnate Frederick Leyland—one of his first major
patrons. The flattened basketweave patterns on the wall and floor are repeated
in the frame, designed by the artist, and reflecting his enthusiasm for Japanese
art. So do the almond branches and his emblematic signature at the right,
about halfway up the picture—a stylized butterfly based on his initials, and
conceived to harmonize with his exquisite compositions.

To the left of the doorway is Whistler's portrait of *Lady Meux*. Though
this colorful character began her adult life as an actress, she managed to
marry Sir Henry Meux—a rich and handsome brewer. But despite his wealth
and social prestige, his wife remained an outcast in Victorian society. In this
second of three portraits commissioned by the devoted Sir Henry, Whistler
presents Lady Meux glancing flirtatiously over her shoulder. She was famed
for her violet eyes. Photographs reveal that she was much chubbier than
she appears in Whistler's portrait.

Van Dyck

Paola Adorno,
Marchesa di Brignole Sale (?)
Oil, on canvas
90 ⅞ × 61 ⅝ in. (230.8 × 156.5 cm)
Painted between 1622 and 1627
Acc. No. 14.1.43

Van Dyck

James, Seventh Earl of Derby,
His Lady and Child
Oil, on canvas
97 × 84 ⅛ in. (246.4 × 213.7 cm)
Painted between 1632 and 1641
Acc. No. 13.1.40

Mr. Frick bought more paintings by Sir Anthony Van Dyck than by any other artist. He owned eight portraits, from all periods of the Flemish artist's life—Van Dyck worked in Antwerp, Genoa, Paris, and London, and died at the age of forty-two. This lavish portrait of *Paola Adorno* was painted in the rich shipping city of Genoa, where he lived from 1621 to 1627.

It is a perfect example of the kind of stately, elegant portrait Van Dyck conceived for Genoese society. He elongates her proportions and paints her from below, so that she seems incredibly tall. It was a way of flattering his subjects, making them as lofty as possible. She looks out at us, but we look up at her. The gold-embroidered gown she wears is an extraordinary object in itself, like her splendid ruff, plumed tiara, and cascading drapery.

Directly across the gallery, you'll find the type of imposing group portrait that Van Dyck perfected during his final years in England. There he became principal painter to King Charles I, a great promoter of the arts.

In this painting, James Stanley, seventh Earl of Derby, points to an island in the background, perhaps the Isle of Man which the Derbys had long ruled over. An ardent Royalist during the Civil War, he was captured, convicted of high treason, and executed in 1651. His formidable wife was equally zealous, conducting the defense of the family's country seat during a three-month siege at the outbreak of hostilities.

But of course it's the little girl who gets everyone's heart beating. One of the greatest child portraitists in the history of art, Van Dyck captures all the bottled-up mischief of this enticing creature—in spite of her stately orange dress, a reference to her descent from the House of Orange.

Millet

Woman Sewing by Lamplight
Oil, on canvas
39 ⅝ × 32 ¼ in. (100.7 × 81.9 cm)
Signed: *J.F. Millet*
Painted in 1870–2
Acc. No. 06.1.89

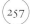
(257)

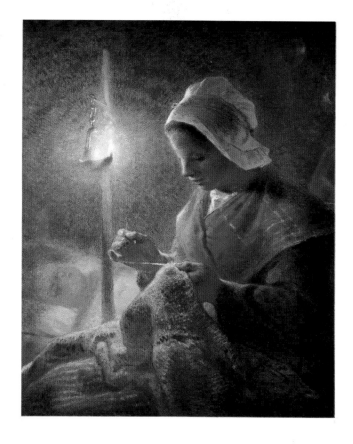

Jean-François Millet (1814–75)
The son of Norman peasants, Millet studied in Cherbourg and then moved to Paris to train in the studio of Paul Delaroche. Although he submitted works to Salons in the 1840s, it was not until 1848 that he began to exhibit the paintings of peasant subjects for which he is best known. Millet moved in 1849 to Barbizon, where he lived for most of the remainder of his life.

Some have suggested that Virgil's bucolic Latin poems inspired this haunting picture by Jean-François Millet. Others have proposed seventeenth-century Dutch genre paintings. But the source of the subject is probably closer to home, for this was painted in the village of Barbizon where Millet—son of Norman peasants—spent much of his life, with his wife and fourteen children.

In 1872, the year he finished this painting, Millet wrote to a friend: "I write this today, November 6th at 9 o'clock in the evening. Everyone is at work around me, sewing, and darning stockings. The table is covered with bits of cloth and balls of yarn. I watch from time to time the effects produced on all this by the light of the lamp. Those who work around me at the table are my wife and grown-up daughters."

It makes you feel as if you're standing at the artist's side.

Millet praises the virtues of simple peasant life in all of his paintings, but there is nothing saccharine about them. Here, the young mother mends a lambskin with quiet dignity, her spinning wheel waiting behind her and her baby sleeping in the warm light of an oil lamp suspended from a pole.

The American critic Wyatt Eaton later recorded his reaction to this picture when he saw it in Paris in 1873: "The reality of this scene, the naturalness of movement, the perfection of expression, the charm," he wrote, "separated it from all other pictures, and from that moment Millet was to me the greatest of modern painters." Van Gogh paid homage to it as well, by painting a version of his own.

Whistler

Arrangement in Black and Brown: Miss Rosa Corder

Oil, on canvas

75 × 36 ⅜ in. (192.4 × 92.4 cm)

Painted in 1875–8

Acc. No. 14.1.134

Whistler

Arrangement in Black and Gold: Comte Robert de Montesquiou-Fezensac

Oil, on canvas

82 ⅛ × 36 ⅛ in. (208.6 × 91.8 cm)

Signed with the butterfly monogram

Painted in 1891–2

Acc. No. 14.1.131

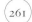

261

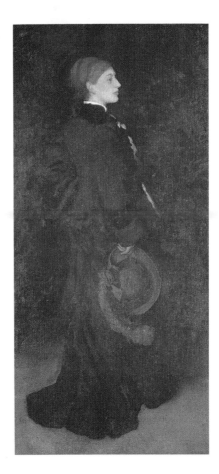

The two grand, somber portraits at the end of the room belong to a series of so-called "black" portraits that Whistler painted at various stages of his career. They are evidence of Mr. Frick's rather daring excursion into modern art in the last years of his life and of his decision to admit only one American artist—Whistler—into the pantheon of his Old Masters. Gilbert Stuart was included too, but solely because of the subject of his painting— George Washington.

By giving these two portraits musical or abstract titles—*Arrangement in Black and Brown* and *Arrangement in Black and Gold*—Whistler was stressing his concern with formal values over mere representation. His use of a palette dominated by black further accentuated this orientation and brought him close to total abstraction, such as we are used to seeing in paintings by Mark Rothko or Ad Reinhardt.

Nevertheless, the subjects of the portraits are not lost, but emerge from their gloom like shimmering ghosts. This effect was noted by a contemporary of Whistler, who said of Montesquiou's image: "this apparition seems to escape from the shadows and advance toward you."

Rosa Corder, on the left, was an artist herself, painting dogs, horses, and even human subjects. She was the lover of Whistler's agent, Charles Howell. Comte Robert de Montesquiou, on the right, was a grand French aristocrat, a prolific if mechanical poet, and the inspiration for the unforgettable figure of the Baron de Charlus in Proust's *Remembrance of Things Past*.

Chardin
Lady with a Bird-Organ
Oil, on canvas
20 × 17 in. (50.8 × 43.2 cm)
Painted in 1753(?)
Acc. No. 26.1.22

Chardin
Still Life with Plums
Oil, on canvas
17 ¾ × 19 ¾ in. (45.1 × 50.2 cm)
Signed: *chardin*
Painted about 1730
Acc. No. 45.1.152

Jean-Siméon Chardin (1699–1779)
*Born in Paris, Chardin entered the
Academy in 1728 as a genre painter,
after studying with Pierre-Jacques
Cazes, Noël-Nicolas Coypel, and
Jean-Baptiste Vanloo. He attracted the
patronage of Louis XV, several members
of the French court, and foreign collec-
tors, for whom he executed still lifes and
paintings of middle-class domestic life.*

The two small paintings on either side of Claude Lorrain's enormous
Sermon on the Mount were painted by the same artist—Chardin—but show
him working in two very different manners, twenty years apart.

The *Still Life with Plums* on the left—the only still life in The Frick
Collection—is a classic example of the artist's rough-hewn early style.
Turning away from the lavish and complex productions of his Dutch
predecessors, Chardin reduced the number and type of ingredients of his
still life to things that any of us could pull together in the kitchen today:
a basket of plums, two summer squash, a glass of water, and an empty
wine bottle. He then arranged these in the architectonic order of a low
pyramid, just unbalanced enough to be lively. But it was the illusionistic
realism of his pictures that enchanted Chardin's contemporaries, who
called it "magic": that faint bluish blush on the plums, the rough texture of
the squash, the highlight on the bottle that alone makes us think we see
the room in which it was painted.

Moving to the right, we see Chardin's *Lady with a Bird-Organ*—
his last figural composition, painted on commission for Louis XV around
1753. He has depicted a middle-class lady training a caged canary to
sing by playing a precursor of the phonograph, known as a bird-organ.
The porcelain-like finish and muted, silvery coloration are quite unlike
the vigorous *Still Life* to the left.

Claude Lorrain

The Sermon on the Mount
Oil, on canvas
67 ½ × 102 ¼ in. (171.4 × 259.7 cm)
Painted in 1656
Acc. No. 45.1.152

Claude Lorrain (1604/05–82)
Claude Gellée was called Lorrain after his native French province, Lorraine. He settled at a young age in Rome, where he spent most of his life, apart from a two-year stay in Naples and a return to Lorraine between 1625 and 1627. Claude received international acclaim for his pastoral landscape paintings.

High up, on top of the wooded summit of Mount Tabor, Christ, surrounded by the twelve Apostles, is shown preaching to the multitude gathered below. The event is that described in the Gospel of Matthew, which reads: "When he saw the crowds he went up the hill. There he took his seat, and when his disciples gathered round him he began to address them." It was in this discourse that Jesus set forth the principles of the Christian ethic through the Beatitudes ("blest are the peacemakers; God shall call them his sons") and instituted the Lord's Prayer. The crowds that Matthew describes as "astounded at his teaching" are vividly depicted by Claude among the absorbed and gesticulating foreground figures, whose diminishing sizes enhance the dramatic spatial effects of this enormous picture. Claude has compressed the geography of the Holy Land, placing on the right distant Mount Lebanon and the Sea of Galilee, on the left the Dead Sea and the River Jordan.

Making such a verbal and mystical subject easy to read in visual form was already quite an accomplishment. Presenting it as a vast and noble landscape whose luminosity can be appreciated two galleries away was an artistic miracle.

Though this painting was acquired over forty years after Mr. Frick's death, he almost certainly would have approved of it, for *The Sermon on the Mount* was one of his favorite passages of Scripture. In fact, it was read at his funeral.

David

Comtesse Daru

Oil, on canvas

32 ⅛ × 25 ⅝ in. (81.6 × 65.2 cm)

Signed and dated: *L. David / 1810*

Acc. No. 37.1.140

Jacques-Louis David (1748–1825)
A native of Paris, David won the Prix de Rome in 1774 and spent the next five years residing in Italy. David was a successful portraitist and history painter, whose work displays his commitment to the Revolution and the Napoleonic Empire. After 1785 he became the official painter to Napoleon, whose political downfall forced David to flee to Brussels, where he resided from 1816 until his death.

Jacques-Louis David painted this sympathetic portrait of the Comtesse Daru as a surprise gift to her husband, who served Napoleon as Secretary of State and Minister of War. We associate David with the French Revolution and Revolutionary figures and events, but he soon became Napoleon's official painter. David executed this portrait to thank Daru for finally getting him the hefty payment he was owed for his vast painting of the coronation of Napoleon and Josephine.

David finished this picture at four o'clock on March 14, 1810, while the Count was away on official business, and proudly signed it in the left-hand corner. He had the portrait placed in the Darus' salon to greet the Count upon his return.

This mother of six children wears a bathing-cap-like headdress of white flowers, in harmony with her white satin and muslin gown. The supple cashmere shawl draped around her provides a vibrant contrast to the pallor of the dress and headwear. Her necklace and earrings have long been a source of discussion—England's Princess Margaret pronounced them not emeralds but chalcedony, a type of quartz.

If the Countess doesn't immediately seduce us, she enchanted the great French novelist Stendhal. He described her as "a woman of twenty-seven, rather stout, with dark chestnut hair, black and very thick eyebrows, small, quite sparkling eyes, who likes to be active. Her appearance reveals a warm temperament ... Her features reveal a forceful, frank, and jolly character."

Liotard

Trompe-l'Oeil

Oil, on silk, relined on canvas

9 ½ × 12 ¾ in. (24.1 × 32.4 cm)

Signed and dated: *par J. E. Liotard 1771*

Bequeathed by Lore Heinemann in memory of her husband, Dr. Rudolf J. Heinemann, in 1997

Acc. No. 97.1.182

Jean-Étienne Liotard (1702–89)
Although this Geneva native was never accepted as a member of the French Academy, he enjoyed international fame as a portraitist, still life painter, and draftsman. During his early years he studied with the miniature painter Daniel Gardelle, and then with Jean-Baptiste Massé in Paris before traveling to Italy, Greece, and Constantinople. His talents were admired at the courts of Vienna and Versailles, as well as among the bourgeoisie of Geneva.

While the names of most artists represented in The Frick Collection are familiar, that of Jean-Étienne Liotard is probably not. Born in Switzerland in 1702, this artist became renowned throughout Europe for his portraits executed in pastels.

The little picture before you he called a *trompe-l'œil,* French for "fool the eye." Liotard painted it—on silk—at the age of sixty-nine. He apparently intended it to sum up, visually but also philosophically, his own art. All the paintings around you here were intended to fool your eye, for in reality they are flat surfaces of canvas or wood on which the artist applied pigments in such a way as to create images—of people, objects, places— that our eyes and mind instantly assume to be real. But Liotard pushes this illusionism to the absolute limit, testing our credibility with the deep shadows under the tiny plaster reliefs at the top, for instance, the screws—one brass, one silver—from which they hang, the touches of what seems to be red sealing wax holding down the apparently crumpled bits of paper adorned with what look like drawings. As a background, he painted a board of ordinary pine. "Look what I can do!" Liotard seems to exclaim.

The notations on the illusionistic drawings read, at the left: "Turkish headdress"—a reference to the artist's long sojourn in Constantinople; at the right: "a headdress from Ulm"—a city in southern Germany, where ladies still wore such strange medieval caps.

Greuze
The Wool Winder
Oil, on canvas
29 ⅜ × 24 ⅛ in. (74.6 × 61.3 cm)
Painted probably in 1759
Acc. No. 43.1.148

Jean-Baptiste Greuze (1725–1805)
*A native of Burgundy, Greuze moved
to Paris around 1750 and studied with
Charles-Joseph Natoire at the Academy,
which accepted him as a full member in
1769. He first exhibited his paintings
at the Salon in 1755, the same year he
embarked on a two-year visit to Italy.
He is best known for genre scenes
and portraits, as well as for his skill as
a draftsman.*

Mademoiselle's little cat has its eye pointedly fixed on the ball of yarn it is helping its mistress unwind, but hers is focused elsewhere, daydreaming or recollecting something. Giving form to such subtle and evanescent states of mind was a speciality of Greuze, particularly when depicting the very young.

See the letter B carved into the top rail of the chair? It's probably a reference to the maiden name of the artist's wife, Anne-Gabrielle Babuti, whom he married in 1759, the year this picture was first exhibited. The subject of it may have been her younger sister. Around this time Greuze painted portraits of other members of his new family too—his wife, her brother, and her father.

The Wool Winder demonstrates the varieties of effects Greuze was capable of achieving in his early work: the luminous transparence of young flesh, the gleaming detail of fingernails, the feel of cold metal in the suspended scissors, the froth of billowing, soft fabrics, the delicacy of hair, both human and feline. But he was also the master of composition. See how everything here builds into a pyramid, its apex at the center of her brow. Against the blank, gray-blue background, the pyramid assumes three-dimensional form, virtually spilling out at us.

Among the collectors who owned this painting at one time was La Live de Jully, an enthusiastic collector of Greuze's work, who tried to form a sort of museum of modern French art back in the 1750s.

Severo da Ravenna
Neptune on a Sea-Monster
Bronze
H. overall 16 ⅞ in. (42.9 cm);
L. 11 ½ in. (29.1 cm)
Made in the late fifteenth or early
sixteenth century
Acc. No. 16.2.12

Severo da Ravenna
Sea-Monster
Bronze
H. 4 ½ in. (11.4 cm);
L. 9 ¾ in. (24.7 cm)
Inscribed: O[PUS].SEVERI.RA
Made in the late fifteenth or early
sixteenth century
Gift of Eugene and Clare Thaw
in 1997 in honor of Charles
Ryskamp and in memory of
Ruth Blumka
Acc. No. 97.2.103

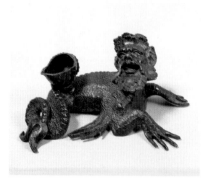

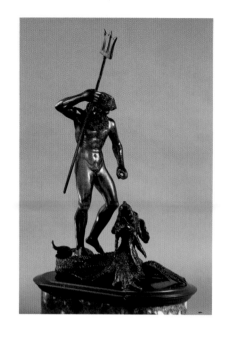

Severo da Ravenna (Severo Calzetta)
(active *c.*1496–*c.*1543)
While little documentation survives
about Severo, his skill as a sculptor was
recognized by his contemporaries. He
was first recorded working in Ravenna
in 1496 and later practiced in Ferrara
and Padua, where he took Riccio's place
as that city's most gifted bronze sculptor.

The splendid beast supporting Neptune belongs to an extended family
of sea-monsters, perhaps inspired by Mantegna's famous print *The Battle of*
the Sea Gods. Only recently have they been attributed to the late fifteenth-
to early sixteenth-century sculptor Severo Calzetta, called Severo da
Ravenna. Presented either in tandem with a god, as shown here, or alone,
these bronze creatures were the most popular of the many decorative,
often useful, small bronzes produced by Severo and his prolific workshop.

The well-proportioned figure of this Neptune, the wildly original
sea-monster, and the beautiful finish of this piece make it the finest of
all Severo's sculptures. The scaly creature is a truly mad invention with its
coiled tail, splayed finger-like claws, and tongue lashing between gaping
fangs. In the tradition of an invincible hero vanquishing the forces of
darkness and terror, the god brandishes his trident as he rides the monster
in triumph.

Nearby, on the chest under the large portrait of Lord Derby and his
family, you'll find another little monster by Severo. This monster is full of
pathos. Its face is fully human, looking up with an expression approaching
pain or fright—perhaps a man transformed into a monster, as in Kafka's
Metamorphosis. The life-sized seashell on this creature's back was used as an
inkwell—beneath it is the artist's only known signature. That signature
enabled scholars to attribute numerous bronzes long thought to be by others
to Severo and his workshop, making this bronze one of the Frick's greatest
acquisitions. It was given to the Collection by Mr. and Mrs. Eugene Victor
Thaw, to honor our former director Charles Ryskamp, and in memory
of Ruth Blumka, who once owned this sculpture.

Pollaiuolo

Hercules

Bronze

H. overall 17 ⅝ in. (44.1 cm)

Made probably in the late fifteenth
century

Acc. No. 16.2.5

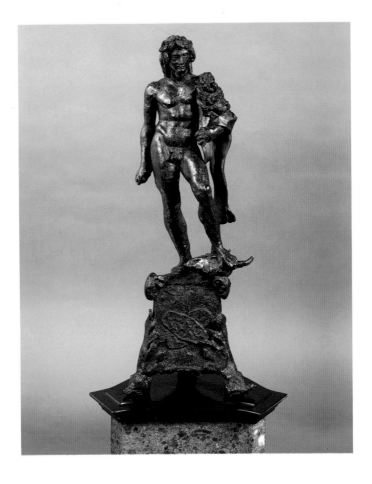

Antonio del Pollaiuolo (*c.*1432–98)
*Antonio Pollaiuolo was trained as a
goldsmith and bronze sculptor, perhaps
in the Florentine workshop of Lorenzo
Ghiberti. In addition to sculpture,
he executed drawings, paintings,
engravings, and embroidery designs
for distinguished patrons, such as
Lorenzo de' Medici, Duke Ludovico
Sforza of Milan, and the papal
court in Rome.*

This compelling image of masculine beauty is one of the most famous—
and favorite—bronzes in The Frick Collection, an image of such power
that people really just stop in their tracks before it. It was made by
Florentine Renaissance artist Antonio Benci, called "del Pollaiuolo"—
or "of the chicken-seller"—after his father's poultry business. Pollaiuolo
excelled in virtually all the arts and was a favorite of the Medici, who
declared him "principal master of the city." In depicting Hercules, the
legendary founder of Florence, Pollaiuolo presented not only the emblem
of the city, but of the Medici as well.

Hercules symbolizes virtuous strength over tyranny, and this virile
bronze figure radiates power. He flings his attribute, the lion's pelt, over
his shoulder, and props his left foot with assurance on a horned skull. The
skull may signify that he represents Hercules Invictus, or "Unconquered,"
whom the ancient Romans honored once a year by sacrificing a bull.

The sculpture and pedestal may have been cast from a damaged wax
model, which explains why they look unfinished. But that's part of the
appeal—the roughness seems completely appropriate to this image of
invincibility and powerful, physical force.

Pollaiuolo was an early master of small freestanding bronzes—a form
that grew in popularity during the later fifteenth century. Such small
statues were usually seen from all sides because they were picked up and
handled; Hercules has been put on a pedestal, so that you, too, can
appreciate him from many points of view.

Boulle

Kneehole Desk with Tendril Marquetry
Oak, fir, and walnut, veneered with
panels of brass inlaid with tortoiseshell
marquetry, mounted with gilt bronze
H. 30 ¾ in. (78.1 cm); W. 57 ⅞ in.
(147 cm); D. 29 ⅛ in. (74 cm)
Made about 1700
Acc. No. 18.5.101

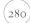

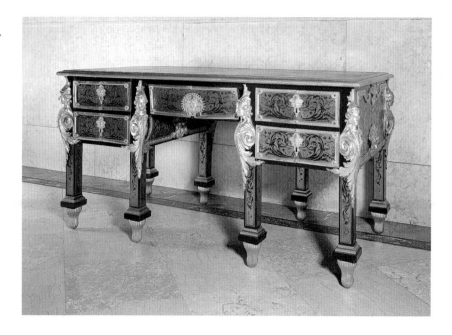

You may already have encountered veneered Boulle furniture of this type
in the Living Hall of The Frick Collection. Here you see a magnificent
eight-legged desk surely made by the master himself, André-Charles Boulle,
around 1700.

All of the vertical surfaces of this desk are covered with a veneer of
tortoiseshell and brass, framed by ebony. Although this sumptuous style
of marquetry originated in Italy, it was brought to perfection in Boulle's
workshop and has ever since become synonymous with his name. In this
technique, sheets of brass and tortoiseshell are temporarily glued together,
and the design is cut out with a special saw. Each material can thus serve
as background for the other. Here, Boulle's characteristic design of scrolling
vines is executed in engraved tortoiseshell on a ground of brass.

These ornate marquetry panels are set off by the eight gilt-bronze
mounts set at the corners of the drawer-cases, representing nymphs rising
from leafy scrolls. Along with the masks of laurel-wreathed nymphs and
the central satyr-mask keyhole escutcheons, they continue the sylvan motif
of the tendril marquetry. Upon an object of such imposing majesty, they
lend a more light-hearted spirit and naturalness. They also seem slightly
surrealist in their combination of realism and decorative abstraction.

Although furniture like this may have been actually used for a time,
it soon came to be regarded as a work of art, like sculpture, to be admired
solely for its beauty.

Garden Court
and Music Room

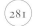

John Russell Pope (1873–1937)
Abandoning his early hopes for a
medical career, Pope took up architectur-
al studies in 1891, later studying in
Rome and at the École des Beaux-Arts
in Paris. He returned to New York
in 1900, beginning his career in
the firm of Bruce Price before working
independently. His private and public
commissions exhibit his severe form
of neoclassicism, which would become an
American trademark. Among his
projects are private residences in
New York and Rhode Island, public
monuments, New England university
campuses, and museum galleries in
America and England.

In Mr. Frick's day, this space was an open courtyard that automobiles drove through. As part of the conversion from private residence to public museum in the early 1930s, architect John Russell Pope converted it into this delightful Garden Court. Now, people love to relax here with the greenery, the sound of water, and, of course, those charming little frogs squatting at each end of the pool.

Pope, known for his classical designs, modeled the Garden Court after a grand Roman atrium, and it would become the prototype for the architecture of many later museums. Beneath the vaulted skylight, paired columns surround the pool with its majestic fountain. We try to bring a little nature inside on a seasonal basis—flowering things in spring, for instance, and the soft green of ferns in summer. The large palms in the corners live here year-round, a staple of Victorian England perfectly suited to this setting.

Just off a corner of the Garden Court, on your way to the East Gallery, you'll find the entrance to the round Music Room. Lectures and special concerts have been offered free to the public in the Music Room since the late 1930s. Generations of art historians have felt honored to speak here, and T. S. Eliot once read from his poems in this room. Some of the greatest musicians of the twentieth century have performed here too, including Isaac Stern, Alfred Brendel, and Wanda Landowska, who insisted that this was the only place suitable for her final concert.

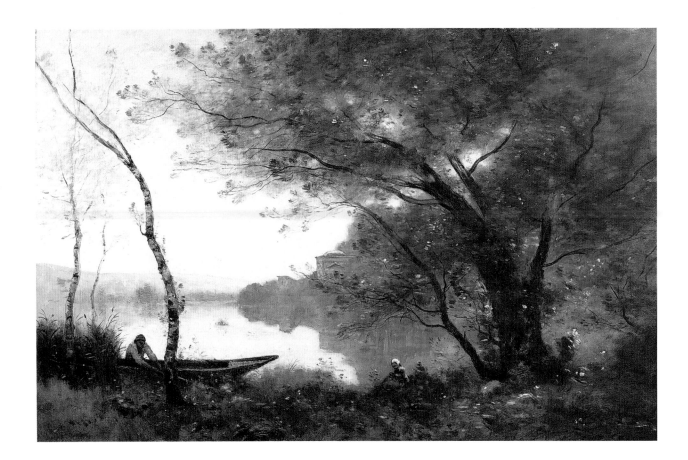

Corot

The Boatman of Mortefontaine

Oil, on canvas

24 × 35 ⅜ in. (60.9 × 89.8 cm)

Signed: COROT

Painted about 1865–70

Acc. No. 03.1.24

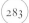

The quintessential Frick painting, Corot's *Boatman of Mortefontaine*, corresponds precisely, and profoundly, with the simple statement Mr. Frick's daughter made about his collecting aims: "He liked paintings that were pleasant to live with." For a man whose professional and private life were frequently beset with drama, tension, and sorrow, what could have been more consoling than the feathery textures and cool, muted harmonies of this picture?

Though a park called Mortefontaine actually exists, not far from Paris near Senlis, Corot's landscape does not represent, in any realistic sense, that particular place. Rather it calls up more a state of mind, at rest, at peace. Corot deliberately sought calm in every aspect of this picture, even to the point of showing the punt in the act of being moored to the bank rather than being disengaged from it. Through a veil of misty foliage, our eyes are drawn across the still, silvery water to a domed *tempietto* on the opposite shore. The building's classical form evokes another age and another land— the landscapes, real or poetic, of Italy. Corot had known these in his youth and alludes to them here in the most subtle way, introducing a sense of time past and time remembered.

Note how ingeniously Corot has echoed the slender silhouette of the boat, vigorously indicated at lower left, in the soft blur of the point of land and its reflection in the center of the picture. This contrast firmly establishes the illusion of space.

Barbet

Angel

Bronze

H. overall 46 $^{11}/_{16}$ in. (118.6 cm)

Inscribed: *le xxviii jour de mars / lan mil cccc lx+xv jehan barbet dit de lion fist cest angelot*

Acc. No. 43.2.82

(285)

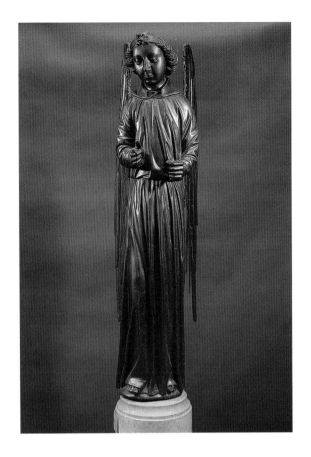

Jean Barbet (active 1475–d.1514) *Barbet is documented after 1491 as the* cannonier du roy *in Lyon. His duties included maintaining the city's artillery and casting cannons and cannonballs. The Frick bronze angel, inscribed by him in 1475, is his only known artwork.*

Beloved by generations of visitors, the bronze *Angel* that presides over the Garden Court might be called the tutelary spirit of The Frick Collection. Everything contributes to a sense of serenity in this earthbound angel. From the strong vertical axis of his columnar body, accentuated by the deep folds of his robe, his head tips gently forward and to the right, revealing a beautiful face and benign expression. Behind him, at rest, hangs a magnificent pair of huge feathered wings. But our angel does not look as if he will be needing them soon. The only hints of motion are in his slightly bent knee and his elongated pointing finger. The closed hand may have once held a staff.

The sculpture is flawlessly cast in one piece, except for the wings, which are attached by pins inserted through sockets. On the left wing, an inscription in Latin informs us that "on the 28th day of March in the year 1460 + 15, Jean Barbet, called of Lyon, made this angel." Listed in town records as cannonmaker to the King, Barbet was undoubtedly the craftsman, not the designer of the piece.

Where this work originally stood is not known, although it has been unofficially connected with the Sainte-Chapelle in Paris. Before alighting here in 1943, the angel spent periods of time in the London and New York homes of J. Pierpont Morgan. It is yet another of the many links that tie together the present-day Frick Collection and the Morgan Library.

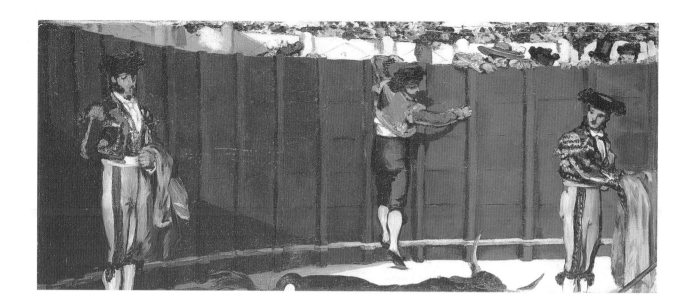

Manet
The Bullfight
Oil, on canvas
18 ⅞ × 42 ⅞ in. (47.9 × 108.9 cm)
Signed: *M.*
Painted in 1864
Acc. No. 14.1.86

Édouard Manet (1832–83)
A student of Thomas Couture, Manet first displayed his work at the Salon of 1861, where his two entries met with favorable reviews. His paintings after 1859 exhibit his strong interest in the artistic tradition and subject matter of Spain, which he finally visited in 1865. Manet received harsh criticism for the works he submitted to the Salon des Refusés of 1863 and the Salons of 1864 and 1865. Official recognition came only in 1881, when he was awarded the Legion of Honor.

Painted in 1864, this work is by no means the latest in date in the Collection, but it is one of the most modern in feeling. The flat, strong colors applied in broad brushstokes, the abrupt transitions between light and shadow, and the condensed space announce a bold new shorthand method of representation.

The urbane Frenchman Manet is associated with scenes of contemporary Parisian life, but in his early work he often turned to Spanish themes. A year after painting this canvas, he traveled to Spain—an arduous journey at the time—and attended a bullfight, and, of course, spent hours in front of the paintings by Goya and Velázquez in the Prado.

The unusual format of this canvas and the odd cropping of two of the figures' feet and of most of the bull, are due to the fact that Manet cut into two pieces a painting he had exhibited earlier that year entitled *Incident in a Bullfight*. Wounded by the criticism of his handling of perspective, Manet divided the canvas and reworked both parts. The Frick painting is a section from the upper right hand corner. The larger, bottom half, known as *The Dead Toreador*, is now in the National Gallery of Art. This is not the only instance of Manet's unusual method of reworking a painting; other examples of severed works exist in which the two parts were then developed into independent paintings.

Jonghelinck
The Duke of Alba
Bronze
H. 45 ⅞ in. (116.5 cm)
Inscribed: FERDINAND, / ALBAE / DVX /
IVNGELLINGUS OPTIMO DVCI / 1571
Acc. No. 16.2.61

(300)

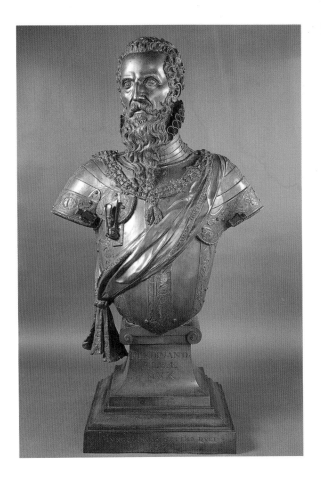

Jacques Jonghelinck (1530–1606)
Jonghelinck first trained with Cornelis
Floris in Antwerp and then entered
the Milanese workshop of Leone Leoni
in 1552. After returning to the
Netherlands, Jonghelinck became his
country's leading bronze sculptor,
also working as a seal-engraver and
a medalist.

Don Fernando Álvarez of Toledo, the Duke of Alba, was one of a succession of Governor Generals to rule the Netherlands when it came under Spanish control in the sixteenth century. In 1571, no doubt to ensure his immortality, Alba commissioned from the native Antwerp sculptor Jonghelinck an over-life-size, full-length bronze sculpture of himself, and had it set up in the citadel of the town. But the Duke's fanatical loyalty to Philip II and the Catholic church, and the ruthlessness with which he suppressed the growing civil and religious freedom sweeping the Low Countries, had already earned him a place in history—or rather, infamy. Philip himself finally put an end to his reign of terror, and recalled him to Madrid. The full-length statue was soon disposed of, but we know it today though this bust-length version that Jonghelinck made at the same time.

A master sculptor and medalmaker, Jonghelinck remained loyal to Spanish rule. But who could envy him this commission? Having trained in Italy, he combined a classical sense of form with a Northerner's eye for realistic detail and his own powerful gift for characterization. The Duke's furrowed brow and set gaze give us a sense of his resolute personality. He is portrayed in armor, wearing the collar of the Golden Fleece around his neck, and a Marshall's sash. Jonghelinck did not idealize his subject. We see the aging Duke just as he was—with receding hairline, bags under his eyes, and deep lines backing away from his mouth.

Index of Artists

Figures in **bold** refer
to the illustrations